VALERIE GILLIES is an award-winning poet v
name. Best known as the river poet who foll
Tay from source to sea, she has held writing
Jordanstone College of Art, Dundee, in East ~~~~~~~~ ~~~ ~~~~~~~~~~,
and at the University of Edinburgh. Her poetry has been published inter-
nationally and translated into Italian and German.

She teaches creative writing in schools, colleges and hospitals. Valerie
lives in Edinburgh with her husband and children.

In her series of portrait studies for *Men and Beasts*, she writes prose
from her working notes for the first time, to accompany her poems and
Rebecca's photographs.

REBECCA MARR is a photographer who was born near Beauly. She has
worked in the Highlands and in Edinburgh and the Lothians on photog-
raphy commissions, and her black and white photographs have been
widely exhibited.

Her commercial work has been used by theatres and newspapers, and in
music promotion. As a sessional artist, she works with groups as diverse
as mental health, HIV and AIDS, Attention Deficit Syndrome, and drug
rehabilitation.

She travelled across Scotland with Valerie to capture this collection of
portraits of men and beasts at home or in their own settings.

# Men and Beasts

wild men and tame animals of Scotland

Poems and Prose by Valerie Gillies
Photographs by Rebecca Marr

**Luath** Press Limited

EDINBURGH

www.luath.co.uk

First Edition 2000

The paper used in this book is acid-free, neutral-sized and recyclable.
It is made from low chlorine pulps produced in a low-energy, low
emission manner from renewable forests.

The publisher acknowledges subsidy from

THE SCOTTISH **ARTS** COUNCIL

towards the publication of this volume.

Printed and bound by
Bell & Bain Ltd., Glasgow

Typeset in 10 point Sabon by
S. Fairgrieve, Edinburgh

What is man without the beasts? If all the beasts were gone,
men would die from great loneliness of spirit, for whatever happens
to the beasts also happens to the man.

Chief Seattle (c.1786 – 1866)

# Acknowledgements

A few of these poems appeared for the first time in *Studies in Photography, New Writing Scotland 17, The Eildon Tree* and in the City Arts Centre Edinburgh Festival Exhibition. Four were printed in *Each Bright Eye, The Chanter's Tune* and *Tweed Journey* (1977, 1989, 1990, all published by Canongate Books).

# Thank You

Our thanks go to Tom McKay, Sebastian Singh Landa, Gordon Sutherland, Archie Morrison, Dawn and Eric Stevens, Antonia Stott, Jim Neville, the late Angus McPhee, David Gray, Dave Scott, Walter Elliot, Michael Renson, Jean Robb, Tom Breheny, Alan Riach, Allister C. Guy, Martin Eadie, Iain Marr, Michael 'Teavarran', Jason Burnett, Rab Graham, Fraser Hunter, John Hanning, Derrick Simmons, Hilda Robertson, Kenneth Cassels, Gill Fyfe, Eugenie, The Andersons, The Duke of Hamilton, Mirren Hutchison, Lucy Montgomerie, Lord Rowallan, Liam Gillies, Mr and Mrs Jackson, the Clydesdale Horse Society, Glyn at Maggie's Centre, Professor Ian Wilmut, the Rosslyn Chapel Association. For practical assistance, we would like to thank art.tm gallery, Inverness, Kirsty Lorenz, Lisa Kapur, Evelyn Pottie and art.tm studio at Inchmore, Gavin MacDougall, Jennie Renton, Joe at JP Cameras and the boys at A'n M Photographics.

# Contents

**Beasts**

# Introduction

Photographer Rebecca Marr and poet Valerie Gillies first met as colleagues in Artlink, leading a range of successful arts projects in psychiatric and general hospitals over five years. Producing the patients' own books and mounting exhibitions of their work in the wards and in hospital galleries meant that it was only last year that they began to experiment with cross-media ideas in their own creative practice.

At the same time, Rebecca was starting over from a lost love and making her own way in the world again, while Valerie was recovering from cancer and its treatment. Imagining their new work, they began to look outwards to a wider vision of the land around them, and they found they were getting on with their lives. While convalescing, Valerie kept in touch by letter with Rebecca who was working in the Highlands. Rebecca would send her new photographs to put up in her writing studio. At this point they realised that a theme was emerging quite naturally, and that the poems and photographs related to it and to one another in an original way. What interested them both was men and beasts.

They realised that if there were to be any more men and beasts in their lives, they needed funding for materials and travel, and a SAC cross-media award won them the chance to turn their pilot project into a book and an exhibition. Two women, from two different regions and different generations, set out across Scotland to look in the eyes of men and beasts to find independent spirits to match their own.

As for the wild men, there was no need to put an ad in the paper asking for replies: they found Rebecca and Valerie. Some are solitaries, some sociable beings, and they are often men who work with animals. Always their individuality is what shines through.

Wild men have their place in poetry and art, from the epic of Gilgamesh to the recent work of Outsider artists. The same wildness and independence is recognisable in the people the writer and photographer are meeting now, whether falconer, farrier, shepherd, geologist, gunner, bee-keeper, jockey, surfer, builder, ferryman, lion-keeper, poacher, crofter or scientist. These are not wild men who camped in the woods, nor are they hermits, but they do stand alone, and each one has about him a sense of timelessness. They are men who do what they love. As men go, they don't come any wilder than Angus McPhee, 'Straw Angus'.

The domestic animals are not pets, though many of them love and live with families, but they retain their natural instincts, to herd, to reproduce, to hunt, to protect, to travel, to forage for food. Human beings need them to survive, to see far into the distance, to scent, to carry, to endure, to run or to fly. They add on to our diminished senses. The success story of beasts through the ages is an indication of all that humans cannot do without them. And they don't come any tamer than Dolly the sheep.

The animals seem wise and benevolent, tame because they live with us. Often we owe our quality of life to these working animals, and we repay them by ensuring their continuing existence. This mutuality is most clear in our relationship with the native breeds of Scotland, which are documented while they are becoming increasingly rare.

Men are difficult to catch – so too are beasts – and Rebecca and Valerie would set out across Scotland with a camera and a notebook and an armful of bribes: giant Bonio biscuits, carrots, home baking and bottles and bottles of whisky. From out-of-the-way places they came in from the cold and dined on stovies and oatcakes and whisky macs.

This is not the definitive study of all the wild men and tame beasts of Scotland, but it is a record of a year's worth of meeting and greeting unique characters, both human and animal. Now the poems exist, the photographs exist, and so too does a friendship with these men and a companionship with the beasts. Poet and photographer have come close into peoples' lives through this year, and that bond has been the basis of the work. Letters arrive for them out of the blue with news of a litter of pups, a success at the show, a tragedy in sheep farming, or a good livestock sale. Their immediacy would be hard to match:

'Am putting nets into Loch Ness tomorrow. Not fun in this wild weather, but the eel smokers are at me all the time. There is a shortage of eels in Europe.'

Most people have enjoyed the singularity of their photographs:

'They mean a lot to me because the landscape is my 'patch', and they are the only record of me and my hound.'

Rebecca has been ferried across a tidal river, galloped over by deerhounds, stung by bees; she studied the inside of a Clydesdale's hoof, had her lens gored by White Park cattle and donned a wetsuit and flippers to follow winter surfers and seals. She was not persuaded to be fired from a cannon by Tam the Gun. Valerie braved the lions (both fur and stone),

flew a falcon, fraternised with poachers, turned archaeologist in a wet field and carded the fleece of cashmere goats.

It's been a happy year and a productive journey. The spirit of these creatures is inexhaustible and Rebecca and Valerie continue to meet new characters. When they observe their point in time they retain the impression that they are tapping into one of the universal themes. They are grateful to their families, who always welcome them on their return. Meanwhile they are setting off on more adventures, still seeing the perfect shot and hearing the perfect poem to fit the theme of *Men and Beasts* for some time to come.

# Men

Only spread a fern-frond over a man's head and
worldly cares are cast out . . .

John Muir (1838-1914) *My First Summer in the Sierra*

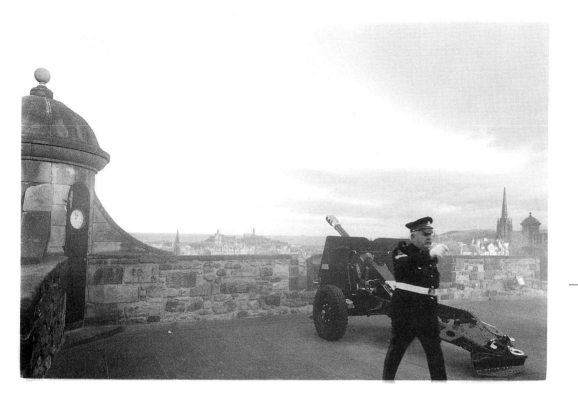

# Tam the Gun

Tam the Gun, Tam the Gun,
one o'clock, see the tourists run!
(local rhyme)

WHAT A NUMBER OF AULD STRENGTHS there are in the south of Scotland: strong places where people kept themselves secure from their enemies, in tower-houses, forts, brochs or castles. One of the most astonishing is Edinburgh Castle, originally a fortified crag like Traprain Law or Arthur's Seat, those other forts perched on volcanic hills. There was always an *auld strength* here from prehistoric times, but what we can see of the castle today spans the 11th to the 18th centuries. To this, our contemporaries have added such diverse works as the Scottish National War Memorial and the new tunnel driven through the heart of the rock in the 1990s.

The Castle was the royal residence of Scottish kings who rode out to hunt among the great oak-woods of the Forest of Drumsheugh which extended over the lands now covered by the old and new city. The rock

is no longer lapped by loch or forest but by the waves of sound rising from the busy streets below.

When I open my back door I see the Castle. From schoolrooms, offices, hospitals, gardens, colleges, from attics or tenement flats, all over Edinburgh people look out at the Castle, their sight-lines homing in on the nucleus round which the city grew.

Mid-November. The day dawns icy cold, with pale white sunshine. It's been a cold night, the wind whuddering across Scotland from the north-west, through the capital city and on to the sea-coast. Rebecca and I are going to visit a particular hero of ours, Staff Sergeant Tom McKay, MBE, so it's time for thermal leggings, woolly hats and gloves, layers of fleece. If it's 0°C in town, it'll be minus 2°C on top of the Castle. Rebecca, of course, is of a different generation, and she is having none of the woolly layers but arrives looking cyberglow chic in a shocking pink mohair cape. We meet in The Hub café on the Royal Mile, walking up the street built on a crag-and-tail formation where we can feel the rock sloping away an inch or two beneath our feet.

Magnet for a million tourists, the Castle has few visitors to brave the cold today. We step out of the Royal Mile with its ghost tours and witcheries up the Esplanade to the Castle gates, where history leans out from every gun-port above. More terrible than any ghost tour is the reality of this Esplanade, these gates. The entrance reveals the natural route along the spur into the fortress. On every other side towers and curtain walls are perched on precipitous bluffs. The broad tarmac where tourist buses park, the setting for the Military Tattoo each summer, is a recent layer imposed over one of the most gory locations in history, the Spur. Here thousands died, sword in hand, in attempts to take the lower part of the Castle. The level was altered in the 18th century, but by then centuries of bloodshed had stained the rocks of the Spur.

Here is a scene from the 17th century, when the besieging Covenanters met a bitter defence of the Castle by Sir Patrick Ruthven, 'whose cannonade imperilled the whole city and the beautiful spire of St Giles's; while poor people reaping in the fields at a distance were sometimes killed by it.' The Covenanters blew up the south-east angle of the Spur, but had little hope of getting through the breach, 'especially as old Ruthven, in his rich armour and plumed hat, appeared at the summit heading a band of pikes. At last the Laird of Drum and a Captain Weddal, at the head of 185 men, under a murderous matchlock fire,

made a headlong rush, but ere they gained the gap, a cannon loaded nearly to the muzzle with musket-balls was depressed to sweep it, and did so with awful effect…twenty men were blown to shreds, Weddal had both thighs broken…' (Grant's, *Old and New Edinburgh*). After a blockade of five months and the loss of some 1,000 lives in all, Ruthven was so weakened by scurvy he could barely walk out of the Castle at the head of his men.

The show of strength and flamboyant skills of the annual Tattoo take place on the site of a hidden history of bravery and slaughter. Each year when the lone piper plays, the lament resounds down the centuries. Here invisible armies clash, and the path we follow so easily now over the bridge and winding round the northern side of the rock, is one which thousands of armed men must have trod, on the Great Thoroughfare of time.

This is the Castle of which Burns wrote:

> There, watching high the least alarms,
>     Thy rough, rude fortress gleams afar;
> Like some bold vet'ran, gray in arms,
>     And marked with many a seamy scar;
> The ponderous wall and massy bar,
>     Grim-rising o'er the rugged rock,
> Have oft withstood assailing war,
>     And oft repelled th' invader's shock.

These battlements rang with the wail that rose through the streets of the old town in September 1513, the sound of families lamenting the news of the defeat at Flodden, a cry that swept up to the walls of the Castle.

Inside the citadel of the Castle, the 11th century St Margaret's chapel stands on the rock. A tiny oratory, 26 feet by 10 feet, spanned by a chancel arch covered with zig-zag mouldings, it keeps a stillness at its core even when queues of visitors press inside. Margaret, the beautiful and pious queen of Malcolm III, was truly a people's princess. We're told 'she daily fed three hundred' poor people, and for those expenses 'she parted with her own royal dresses.'

After Queen Margaret's death, her children were terrified to find the Castle surrounded by an army of fierce western Highlanders 'in the dun deer's hide, striped breacan, and hauberks or lurichs of jingling rings.' The children escaped by the west postern, and her son Prince Edgar later recovered the throne by his sword.

In contrast to the calm brightness of Queen Margaret's chapel, a prison known as the Dark Pit is hewn out of the rock, which became a 'black hole' to many Jacobites. Another dark story of the Castle is told in the local ballad of outrage, probably composed in the 1430s:

> Edinburgh Castle, town and tower,
>> God grant you sink for sin!
> And that e'en for the black dinner
>> Earl Douglas got therein.

This refers to the sixteen year old Earl of Douglas, Lord of Galloway, lured into the Castle by an invitation to a royal banquet, when he was seized and beheaded in front of the boy king James II.

So many eagles have perched in this eyrie, where the Crown Room holds the same crown which glittered on the tough skull of the Bruce and on the red-haired head of Mary Queen of Scots. The Castle contains some of the ambiguities of the world, just as you and I embrace them within ourselves. Here flourished heroes and cowards, the battle-scarred and the beautiful, the brave and the terrified.

In the few minutes before we meet up with Tam, I show Rebecca the very summit of the rock which I first visited as a child, lifted up by my grandfather to read in the regimental books of those killed in the First World War. Holding the names of his own comrades and trench-companions, and of his brother, the memorial became his and his nation's monument. Here, where the topmost rock emerges through the floor of the chapel, is the tribal totem, the bit of basalt that represents the land itself.

It's a place where we ask questions about the meaning of what happens to us, and whether we can make out a continuity in human life. While 'killing time', we feel it as concrete history. The paradox is that time can also be suspended. On the brink of the platform, at his gun-port, a gunner hovers on the brink of the future.

We've returned to Mills Mount battery. While we're wondering what time is, it would be a good idea to ask the weel-kent figure who disappears in a puff of smoke every day – Tam the Gun.

Tom McKay first got the name 'Tam the Gun' from one of the Castle warders. 'I absolutely detested it, but it's stuck to me like glue.' Now there's a model Tam in the exhibition, and in the future any successor the Army selects to take his place may have to be called 'Tam' too.

The cannons of the Castle tell their tales with a bang. Many an Edinburgh citizen has triumphed in a moment of childhood, sitting astride the greatest of them, Mons Meg, 'that mighty bombard'. No brave little Scot would complain how cold it was to sit there bare-legged. It was enough to feel proud, to be secure in the thought that whoever holds the cannon holds the castle. Mons Meg was forged in Galloway out of iron bars. The legend goes that Brawny Kim the black-smith, assisted by his seven sons, made the cannon in the same way a cooper would make a cask, with staves and hoops. The resulting piece was strong enough to fire balls of granite. The first ball shot from Kim's gun blew away the hand of the Fair Maid of Galloway while she sat in the banqueting hall of Threave Castle, as she was raising the wine cup to her lips.

At one time, Edinburgh Castle held about thirty 'pieces of cannon', as well as 'cut-throats, iron slangs and arquebuses' which defended the parapets. The master gunner, Robert Borthwick, cast 'a set of brass ord-nance' in the Castle which were known as 'the seven sisters of Borthwick' captured at Flodden. The English said there were 'no cannon so beautiful in the arsenal of King Henry'.

King James IV inspected his artillery daily in the Castle, and had a nar-row escape when one of the guns burst, a forcible reminder of how his grandfather, James II, died. To be transported back in time, we have only to look at a door lintel carved with a 16th century cannoneer in full armour loading a small culverin. In those days, the fortress had its own hereditary master-gunner.

Tam the Gun is the longest serving District Gunner since the One o' Clock Gun was first fired in 1861, as a signal for shipping in the Forth. Many people know the gun, but they don't know its story, so Tam had the idea of making an exhibition to show the time gun system worked out by Charles Piazzi Smyth, Astronomer Royal for Scotland. A 4,000ft overhead wire linked it to the visual 'Time Ball' on Calton Hill which moved at a set time each day.

The most famous dog in Edinburgh, the Skye Terrier Greyfriars Bobby, knew when to turn up for his meal in Candlemaker's Row by the sound of the firing of the city's Time Gun. In the 1860s, Colour Sergeant Scott made friends with the dog, and regularly treated him to his meal in the eating-house. When sergeant Scott set off for the Castle workshops, Bobby accompanied him to the end of George IV Bridge before turning and trotting back to Greyfriars Kirkyard.

There are time guns all over the world. Vancouver's fires at 9pm, then there's Signal Hill, South Africa, and Sydney, Australia; all were started by the British Army. Tam's only off-duty days are Sundays, Christmas Day and Good Friday. 'People look on me as the time centre of the world.' He admits to getting a bit twitchy on his day off, wondering, 'What if this is the wrong day, who's going to fire the gun?' He may be relaxing at home, but something seems to be adrift as 1pm approaches. As for the rest of the day, 'I only need to know the time at one o'clock,' he reasons. 'I'm like a Dr Who, in command of time.'

The gun he uses today is a 25-pound howitzer. 'I've only had one type, though I've had different guns. They're like women, they've all got their idiosyncrasies, they can be very temperamental at times. One has a loose trigger, one leans to the left a little bit. I haven't got a favourite.' The best-known is the gun used in the Battle of El Alamein. 'It's the gun that's famous, not the man who fires it. You'd get a monkey to fire it.' When we see Tam looking spick and span in his uniform we're not so sure about that.

Atmospheric pressure causes the sound to vary every day. Snow muffles it, for instance. But Tam promises us, 'You'll get a good crack the day because it's cold.' More ounces of powder are fired for a bigger bang, in the single millennium round for example, which was televised all across the world. In my childhood the gun seemed to be much noisier than nowadays, but the quantity of powder used has varied, from the old 3lb charges, to 16oz for Armistice Day, to the current 8oz charge daily. Even so, you can hear the gun at Holyrood Palace on certain days, and in the past it's been heard as far away as North Berwick and Burntisland.

What's it like to stand beside it? 'It tends to reverberate right up your legs,' says Tam. 'My hearing's all right if anybody's wanting to buy me a drink.'

One o'clock is getting closer. 'You'll be safe here,' says Tam, standing us in a corner of the platform of Mills Mount Battery. 'You'll only get one shot of it going Bang!' He's checking his stopwatch below the clocktower. 'You'll see when I put my hand on the trigger that's twenty seconds to go. When I say to you 'ten', that's ten seconds to go.' There's a silent countdown in our minds, '10...9....' accompanied by Tam's precise, white-gloved movements. All the moves he's got! When the gun is fired, the bang is terrific. If that's only 8oz of powder, think what it's like when it's 3lb. The cloud of smoke lingers for a wee bit, it comes and goes. Tam unloads the shell and it's still smoking. There's an acrid smell of cordite in the wintry air. Boomtime for Tam.

Rebecca has her photos but she says 'My knees went! I got such a fright.' I'd suggested to her earlier that the best photo-shoot in these circumstances might be for her to take pictures while Tam fired her from a cannon, but she isn't up for it.

Tam has invited us into his howff, a tiny building hanging on the edge of the Rock. It can get really wild down here in stormy weather. It is his office, and if he has to sleep overnight in the Castle, he has an army bed and some blankets. His pailful of rags and Duraglit for polishing are just inside the door, and here he cleans his boots; 'I bull my boots, it takes ages.' Military ways of passing time.

Tam looks very relaxed in his jersey, smoking his chunky silver-ringed pipe with a flat bowl. He can set it down on the table. There's a good smell of American Black Cherry tobacco in a clean pipe, just mingling with a whiff of explosives. 'I wonder where the time goes, these days...'

He talks about the guns; 'to move them, I have an 8-tonne truck,' and their range; 'this gun's range is 8-10 miles, over to Inchkeith or to that ship that's beyond it in the Forth.' Once a tourist who thought he fired live ammunition pointed out that this must be why there are no tall buildings and only flat roofs on the trajectory between the gun and the sea. He talks about cordite, remarking that he never smells it any more although he must have explosives on him all the time. The trace is always there, the cordite liquefies, so he's always going to have it under his fingernails. If sniffer dogs search the Castle before the visit of a famous person, they can detect Tam immediately!

We can understand how he loves his duty, up on the heights of the Rock. He tells us when there's a snow blizzard and he puts on his winter great-coat, 'you can be standing by the gun and never see the folk that's watching you because of the snowstorm.' Tam is inside the storm of history.

I recall some of the Castle ghost stories; it's not surprising that it's spooky here. Once a whole regiment raised the alarm inside the fortress because two sentries and Colonel Dundas experienced a 'horrible appari-tion'. They could make out the beat of an old Scots march, and then the French, 'the tread of soldiers marching to the tuck of drum'. Tam thinks, 'If there are ghosts, they're going to be here, inside Edinburgh Castle.'

During sieges and blockades, the dead were often buried within these walls. In 1745, the defenders interred nineteen men and three women on the summit of the rock. Tam observes, 'There's military police at the top of the Castle here twenty four hours a day. They've got big security doors there and even so, they see unauthorised people passing through at night where nobody could possibly go.'

Tam keeps an open mind about ghosts. 'Maybe light shines through dark matter for a brief moment. But last Saturday, 11.30am, there were three of us having a meeting sitting in this room. We all heard footsteps coming down the stairs and coming to the door here. I got up to let him in and there was nobody there.'

Nevertheless, if Tam has to spend the night here, he's quite happy about it. The cannoneers of history would be happy to think of a gunner remaining in the Castle, too. Here is a sonnet that gives an account of a true story, about a strange revenant who returned to the castle after the Battle of Killiecrankie.

# A Spectre in the Castle

Even as Balcarres, a prisoner in Edinburgh Castle,
woke about daybreak, keen to hear news of the battle,
he recognised his friend Claverhouse, *Bonnie Dundee*,
terrible, handsome in his breastplate. He appeared

to pull back the bedcurtains, to look at him
sadly, fixing his gaze on him, then to cross
the chamber, leaning on the mantelpiece for a moment.
He walked out without saying one word.

Never thinking what he saw was an apparition,
Balcarres kept calling out to it to stop. No
answer. Dundee was going elsewhere, a phantom

moving through bastions. Later, Balcarres heard
how it was just as the shadow stood by him, Dundee
drew his last breath near the braes of Killiecrankie.

Pre Historic Male
Endangered Species
DO NOT TALK TO - IT BITES

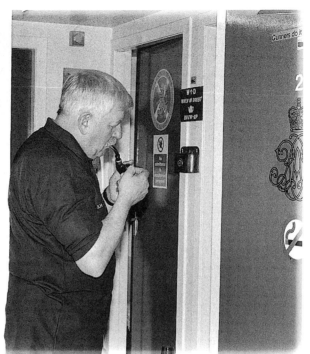

Tam himself measures time, reveals a unit of it every twenty four hours. Incidentally, he reveals its eternal return. He may indicate a short interval, but when Tam disappears in a puff of smoke it is not final, because we hope that this will be followed by tomorrow's gun, just as Tam himself disappears and reappears. Every one o'clock gun repeats the initial *bang* and coincides with it. At one and the same loud moment, it suspends time. In all the ceremonial moves he makes, Tam simultaneously celebrates but abandons history. The gun fires into mythical time, repeats the explosion of an early cannonade. The dramatic repetition of the gun suspends ordinary duration. For an instant we participate in a greater time. This is especially clear in the symbol of the New Year's firing. The Millennium Gun marked a regeneration of time, we were free to begin a new existence.

Tam the Gun, rock-fast in history and recording the hour, restores time to its infinite place. Thank you, Tam, we had a Great Time!

# Black Cat Boy

he jumps off
      the cattery roof
towing a bin liner
      parachute
looking north
      into the distance
to Cat Craig and the sea.

but the boy and cat
      lived in town before:
when she was just
      a kitten
she was trapped
      in a tenement blaze
the firecat
      with a white scar
beside her eye
      the flame fleck
the seed of change.

now summer rays
      shine on them
lying in the field
      while behind him
the hills stretch
      shoulder and hill
in a seamless flow
*Lawmurmairz Lawmurmairz*
      seen from
      below.

black cat guardian
      of darkness
goes for walks in the day
      follows him everywhere
has had two litters
      leaps on feathers
and catches
      mouse and mole.

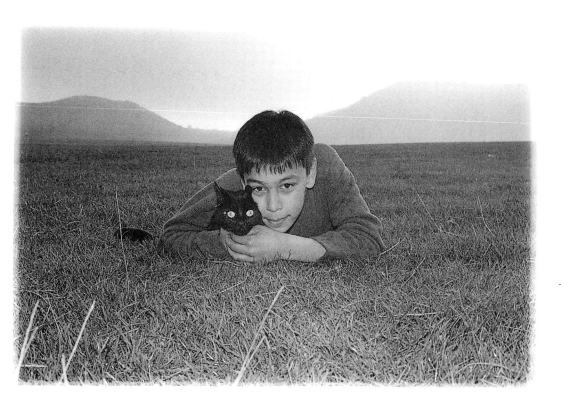

he knows her sound
    under Blaik Law
her rasp of a purr
    dark drones
all the way
    round Boonslie Shank
*Lawmurmairz Lawmurmairz*
what he likes best about her:
    the faces she makes
when she goes to sleep.

# Geologist Gordon

Gordon gorge-crossing
above a hundred-foot drop
oiling the pulley
swaying on the pallet
airwaves above the river

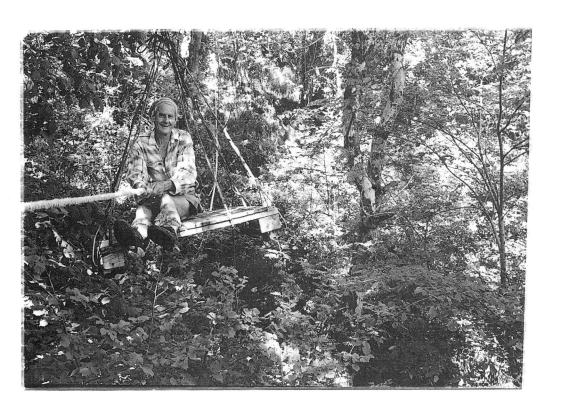

# Skinny-Dipping

skinny-dipping
he's asked all the girls
to go swimming
every century
going down a storm
sliver of silver
torso in the torrent

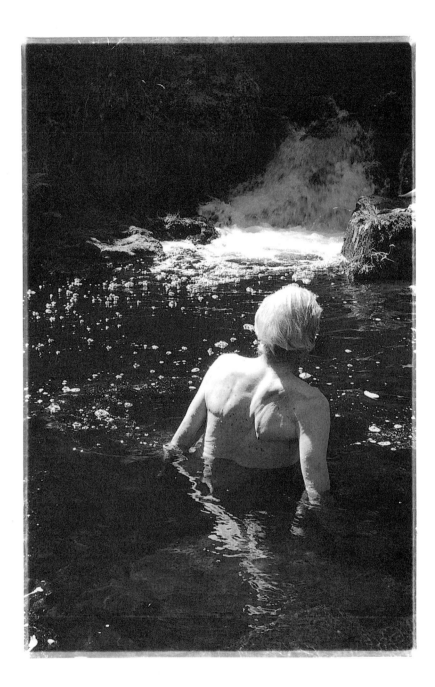

# Archie and his Flock

Flockmaster of a thousand sheep,
the hill breed, quick and hardy,
thrifty, both Archie and his hirsel.

They wear their teeth down, don't
lose them, aye, they hold their teeth.
They thrive in harsh conditions,

produce an exceptional fleece,
the wool strong, firm, white,
dense and of a good staple.

Blackface, a tough adaptable breed,
their horns spring firmly,
close-set at base, curve back and out.

Their ribs are well-sprung,
their backs straight and long,
deep in the flank, a leg at each corner.

The ram is half the flock.
More crimp in his fleece,
their wool fills mattresses in Naples.

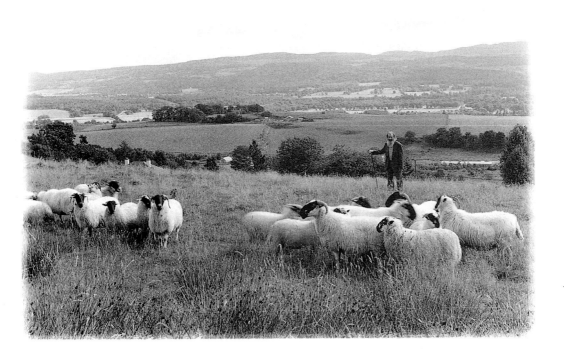

# Hill Lambing

*in homage to John Berger*

There's fleece, horns, hooves, grass, breath, mud,
teeth, mash, dung, blood, afterbirth, milk,
lamb jackets and the noise of bleating,
zinc buckets and a bottle of antiseptic,
pens to be cleaned, syringes to be rinsed,
ice on his boots and a light in his window.

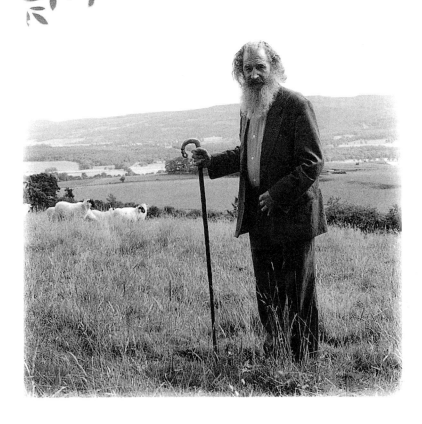

# Aik an Birk

we kin hear the wud threepin
abune the toom steadin
in the laigh howe
o the muir's gowpen

whit a guddle o graith
hings by the coup-cairt
there's roosty gear
by the faa'n-doon lair

while raughter an rib
poke through the byre ruif
an oildrum rammed in the windae
hauden bi a tedder o strae

nae road, nae electricity
anely a strip o trees
birk, aik an hazelraw
mak up the singin schaw

till cauld lugs are sair
*'We belang the bairns.*
*Come bide at the mains*
*tae cry us aik an birk agane.'*

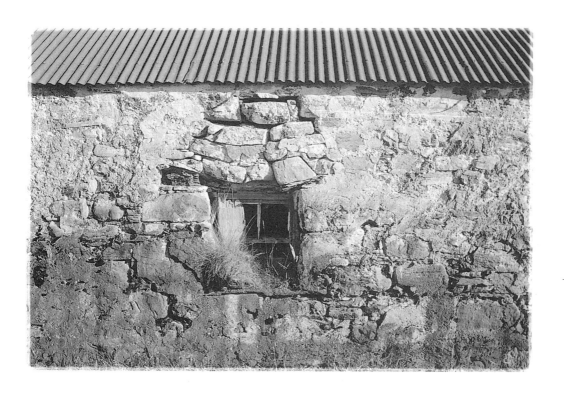

# Straw Angus

*For Angus McPhee. b1916 Outer Hebrides. 1939 Joined Lovat Scouts, with his father's horse (the horse was bought later by an officer for £50). He was sent for training in the Faroes. 1941 Became ill. Inverness hospital for 50 years. The woods and wards of Craig Dunain. 1996 Returned to his native island where he died within 2 months.*

Angus sits crosslegged in the grounds
tying leaves loosely, working them snugly.
Every day he's making ropes and clothes
out of grass, twigs, wool and hay.

Hats, capes, vests, shirts, thigh-boots
for a fisherman,
bridles, halters, harnesses, nosebags
ready for a pony.                                        /Rucksacks

Rucksacks, cornucopia, sower's bags
to broadcast seed,
pouches of birch leaves, beech,
chestnut
thousands of grass ropes.

He casts off in live cloth
stacks it beneath bushes
hangs it from hedges and shrubs
a sign of his being there.

Angus knits a wizard stitch.
Fieldmice nest all winter
in the bag he left behind him
placed under holly bushes.

His knitting-pins are fence-wire,
his vest is sheep's wool off the posts.
His trousers fit a tall man like himself,
their medieval pouch, their rope belt.

His huge jacket is all grass
with basque and poloneck,
with great long sleeves wide open,
it's no canvas straitjacket.

Strong hands reject weak stalks,
cable-stitch netting sunlight.
The knitter takes up the jacket
the jacket alone enters the forest.

Hospital clothes smell of hot salt, bleach.
Straw Angus' clothes are made to last,
his moccasins, his leaf slippers,
his grass boots will step onto the shore.

He has a new purpose for rope.
Against the day of the big storm
he has a halter for a pony in hand
leading him home to the island.

# Jockey

The flat-race jockey rides so short
a bent chick searching for a grain

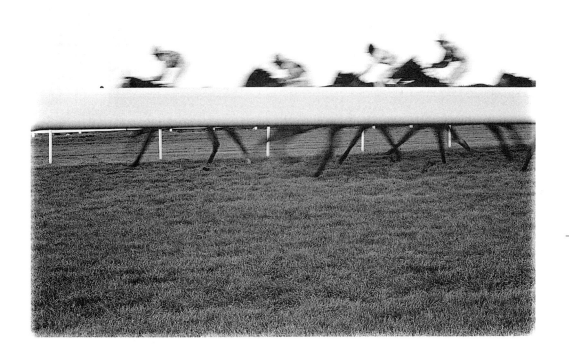

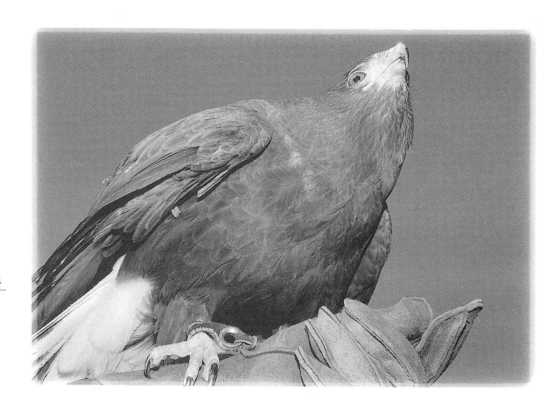

# Falconer

big Harris hawk
hits the glove lightly
air at the core of each feather

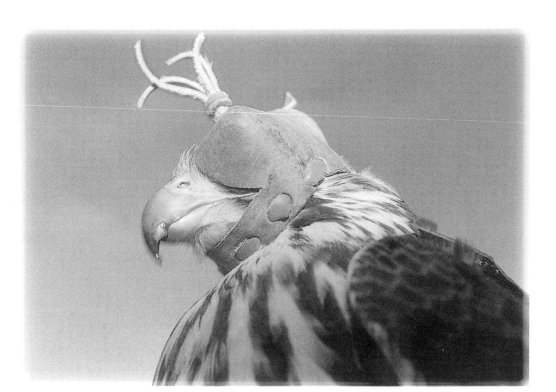

# Owl Calls

wu…wu
w-h-h-h-h-h-h-h-oo
whoo-hoo
hoot-uwaw

huhu hu-hu hu hu hu…hu
huee…huee
he…he…he…hehe…he
hooo

kee-aw   kee-aw
kro kro kra kra kra
kee-wick
hoolet

to-wee   to-wee
tyak…tyarrp
tyto

boo-boo-boo
bu  bu  bu  bo
bubo

ow-ow-ow-ow-ow-ow
oo…oo…oo
ool

huam  huam
who am I?

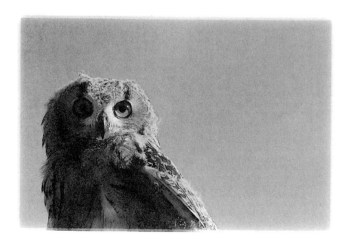

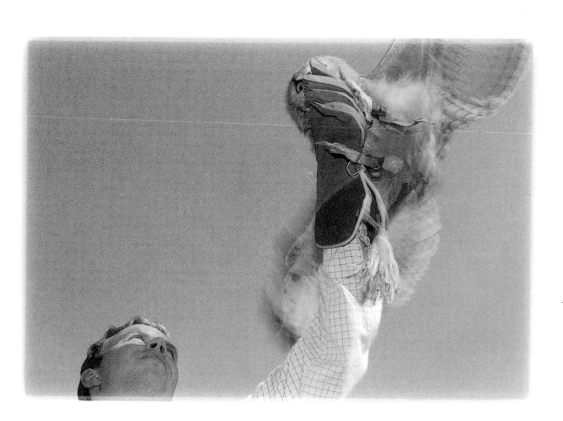

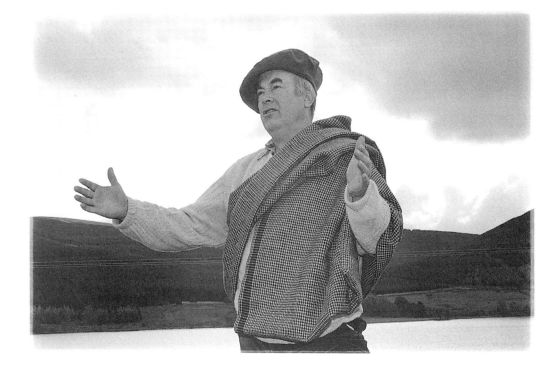

# Fieldwalker

When I was following the River Tweed, making the cycle of poems that were to become *Tweed Journey* I was familiar with the Upper Tweed Valley, but not the lower. Judy Steel introduced me to Walter Elliot, a 'poor but honest woodcutter' who has made his living in the valleys of the Ettrick and the Yarrow. As a fencer, Walter knows the land in a way that you cannot learn from books, but he is also a local historian and fieldwalker. He is the best of guides to the Border.

Walter speaks the rich Scots of his native Ettrick, and his knowledge of Border archaeology, history, literature and language is unsurpassed. To meet Walter is to feel that you've always known him. He likes to describe himself as 'thrawn and cantankerous.' In a thorn-proof coat and black wellies, with observant brown eyes and curly eyebrows, he doesn't look as if he would be blown away easily, rather, he is built to last through centuries. It's true, he played rugby

for Selkirk for eleven years. He has survived concussion and a three-week coma, from 'bein caa'ed ower by a lad on a bike', when he had to learn to talk again. His Braid Scots tongue didn't suffer in the interval.

Walter and I run away together into the hills every few months. There we go to 'his secret places which no living woman has ever seen': hidden valleys and old towers, a hillside with a lost *fogou*, a subterranean tunnel such as you find in Cornwall, waterfalls with a gold-and-red autumn rowan growing straight out of the rocks, mysterious earthworks, unrecorded hill-forts and settlements, a broch overgrown with woods, the lines of a Roman road, the mark of a flint-knapper's fire with its heat-crazed clinkers from long before the time of the Pharaohs.

A mystery tour with Walter is filled with wonderful storytelling, and in the most isolated places, with a sense that there are other ears listening. We can be travelling fast down the Langholm road when Walter will recall that it used to be two tarmac lines with a strip of grass running down the middle. He knows the name of every farm and he has fenced most of them with his team. 'That slope is where I rolled ower wi aa the stobs, and kept rolling till there wasnae a sound o falling machinery. The blacksmith mended the windscreen.' We'll wander through Liddesdale in a 'Liddesdale drow' – the mizzle of rain that soaks you through in five minutes. It's worth it to explore a castle like the Hermitage, to be there standing at the entrance to the prison when a terrific draught blows up from it all of a sudden, an unnatural, underground breeze blowing, pushing past Walter and me in the doorway. Walter carries on with his story:

'Sir Walter Scott was here when they opened it up. The Douglas had left the Ramsay in this prison because he was jealous of his fame, the Ramsay was getting grains dropped by mice from the granary and licking water off the walls. It took him seventeen days to die. It was him right enough, the skeleton wore the Ramsay ring.'

We look up to the buzzard's nest in the tower, an arm-span wide, and it's the moment for another tale of the Warden of the Marches, when Mary Queen of Scots rode south swiftly to visit the injured Earl of Bothwell. And this is the story of how he came to be stabbed in the first place:

'Bothwell captured some Elliots and Armstrongs and flung them into

the prison here. Then he rade oot efter Jock Elliot, whae saw him
comin and took tae the hills. Bothwell had the better horse and shot
Jock through the bodie. Then Bothwell rade up alangside tae finish
him off. But Jock Elliot up and gied him three slashes with his
whinger, then made off. They took the wounded Bothwell back, but
the Elliots had burst oot o the prison and wudna let them in!'

Walter is a skilled storyteller and he can also turn a neat verse. He's
known as the poet of the Yarrow valley, and here he is describing
one of the events at *The Yarrae Show*:

> The horsy lasses, there because
> They haenae onie fears
> O loupin cuddies ower brick waas
> They've practised it for years.
> Gin they get thrawn off at the jumps
> They're raised tae sic reverses
> Tho on their heids a routh o bumps
> An gey sair skin't their erses,
> Hard cheese, Fiona!
> In Yarrae at the Show.

He composed most of his poems while digging post-holes for fences, and
only occasionally wrote them down. 'You'd be digging post-holes, the
big ones, and your mind would be away on something else, I wish I had
pencil and paper with me for all the poems I made up.' And he has a
few books full.

It's a good day when my two friends, Walter and Rebecca, meet for the
first time and get on well. Rebecca has arrived in Selkirk off the
Edinburgh bus, wearing an orange mac and blue mini-kilt with tartan
bag, black camera case, and her silver wellies as an extra.

For the photo-shoot I've asked Walter to wear his great-great-
grandfather's best plaid – the one he'd have gone to the kirk in – to let
Rebecca see the native dress of the Borders over many centuries.
Originally it began as the shepherd's check of black and white.
After being washed in peatwater for 200 years, now it is blue and fawn.
At Newark Castle Walter puts it on and shows Rebecca how to fold it
so that there is a pouch for carrying a lamb. Then he puts on his blue
bonnet, which the museum had borrowed from him as a template for
making lots of wee blue bonnets for Border schoolchildren. He's glad to
have it back.

The Ettrick Shepherd and Walter's great-great-grandfather were on neighbouring farms. When Walter fell asleep during the day, as a wee boy, his grannie would cover him up with this shepherd's plaid, the all-weather clothing of the time. And he would wake beneath it, as his ancestors did, into a continuity of feeling the warmth of the oiled wool and breathing the cold valley air.

We travel further on up the valley, pull on our wellies and climb to St Mary's Kirk above St Mary's Loch. Rebecca photographs Walter striding up ahead with his spring-heeled step on the slope, in his blue and fawn plaid, the moorland colours, and his bright blue bonnet. Time is walking past me. It's too much for Rebecca's Nikon whose batteries give out, so she removes them and licks them into life again like a yowe with a lamb, between each shot. One shot at a time, only. Walter walking towards a line of fence-posts, of his own construction. Within a couple of weeks the winter will set in up here and it will become so wild and bleak, solitary and glorious. We enjoy deep silence, then the sough of a bird's wing, a wild duck flying over. It's growing cool already.

Winter is the hunting season, that means the fieldwalker's best season for discovering traces of earlier cultures on these Border hills. Beautiful bare hills, sometimes obscured by forestry. Archibald Geikie the geologist would have hated to see it: he described planting timber on them as about as natural as putting the torso of the Apollo Belvedere 'into a great coat.' New planting, however, is much more sensibly done, with native woods like the Carrifran project going some way towards restoring our picture of the great Ettrick Forest, a fragment of which survives in out-of-the-way places like Fauldshope Wood, with its ancient oak-trees. Walter describes trees like these as part of our forest gene-bank.

A fieldwalker looking at today's landscape is running a film of a different country through his mind. The ability to recognise man-made features on the land, or precious artefacts lying in a ploughed field, is acquired over time. You are only as good a fieldwalker as your experience lets you be. Walter learnt to fieldwalk with the two Mason brothers and adds on their years to his own. He is generous with his knowledge. I discovered dowsing with divining rods from him, when he taught my youngest child, Mairi, how to find the well in Smailholm Tower, where Walter Scott played as a small boy. Combining dowsing with fieldwalking provides powerful keys to open up the past for the present.

It took Walter a couple of decades to renew peoples' interest in the vast Roman fort and camps at Newstead, the centre of Roman Scotland. The glowing colours of intaglio gems he's found there are on show in the National Museum of Scotland, and sometimes to be seen in the Melrose Exhibition of the Trimontium Trust. '*Trimontium Amo*', 'I love Trimontium', and all the incredible evidence of the past that's been discovered here, especially from the excavations of the archaeologist Curle. He opened up the pits into which auxiliaries (who were Celtic in origin) threw some of their best equipment, as a way of closing the site. In waterlogged pits, with very little oxygen, lay the handles of swords looking as if you could pick them up and use them, or amazing cavalry helmets in bronze, as if they'd been taken off after a parade. At recent rescue excavations, Walter was able to indicate to the professional archaeologists where he has made most finds, and he enjoyed helping at the dig. Here's a sandal, just his size. Now he's looking for the other one.

When you're with Walter the sense of something just about to be discovered is always present. Every fieldwalker has a find of a lifetime: Walter's is probably his little intaglio sealstone of the Emperor Caracalla, which challenged the accepted dates of the Roman occupation of Trimontium. He just walked across the field and found it. It takes a long time to get your eye in, to spot a tiny carved gemstone about the size of your little fingernail among the colourful clods and pebbles of ploughland at Newstead.

My find of a lifetime was made last week. It had been raining for over 24 hours, bitter raw wintry weather in April, the 'yowe-trummle' (ewe-trembler) time for ewes and their newborn lambs, the ewe-trembler. The previous night in Selkirk, in our stockinged feet or moccasins on the wooden floor, we buzzed with the rhythms of Tom Bryan's band, *Wolfwind*. Tom is a Scots-Canadian poet who plays blues on electric mouth-organ and is very much part of Border life now. The evening was billed as '*Tweed and Yarrow*', with Walter and myself appearing as river poets. Walter even sang – to great acclaim – *The Yarrae Show*. One drink in The Queen's Heid afterwards and I drifted off to sleep on the banks of Ettrick. The morn, we'd heard, was to be as wet as the day. But it dawned glittering bright and our plans changed, no indoors day, we're off fieldwalking.

Clouds hurry overhead, it promises to be showery, with sharp moments of sunshine. Perfect conditions for fieldwalking, for catching a glimpse

of the chip, the glint of some treasure turned up in the big field by recent ploughing. The hunting season may end tomorrow when the farmer plants his tatties and there's no more fieldwalking till the autumn. Today is a one-off. We hop over the fence and into the vast ploughland that is all rolling fields to the untutored eye, with nothing to be seen. To the fieldwalker, however, there's a black patch that was the bath-house, the long, lighter clayey colour of the line of the ramparts, a bigger stone or two that's the broken masonry of the granaries.

The rich red-brown soil is absolutely soaking. We plod in wellies while the sun breaks out afresh on each patch in front of us. Not so many people go fieldwalking these days, though many more are keen to use metal-detectors.

Today we're after something that no metal detector can find: a single blue native bead, perhaps, or rarest of all, a Roman sealstone fallen from a ring. Men wore these as thumb-rings to impress wax and their gem-stones often dropped out of the setting.

Even if we don't find anything, we are getting the fresh air. It's impossi-ble, at first sight, there are so many different sparkles and shards of light on top of the soil. Bits of red pebble, Victorian china and glass chips, and the natural chertz in varied colours. Most deluding of all this fool's gold is the live ladybird – just the size, colour and shape of an intaglio – when it shines on a spring day like today.

We walk some yards apart. Walter thinks that when you reach the age where you have to hold the newspaper down a bit to read the small print, at last your eyesight is perfect for fieldwalking. I try to look up about 3 ft ahead, at the same time as curving around, it reminds me of scything. We are stopping and stooping alternately, to turn up an unusu-al stone or a rim protruding from the earth. Here's a palm-sized piece of amphora which shows the curve of the vessel. Perhaps it held olives of which only the stones remain. It's my first find of the day but I know Walter spied it first. Half a field further on we're pausing to raise our eyes to the surrounding landscape, to lengthen our sight and refresh our vision. Several times we cover our ears at the drum-splitting racket of warplanes in pairs slicing round the edge of the Eildon hills. These hills give the site its name, Trimontium, the place of the three hills. Eildon North was the site of a densely-populated native township – traces of over three hundred round houses remain – and intermittently occupied. Their relationship with the Roman fort beneath is yet to be fully understood.

We are fieldwalking within the fort when we come across bits of fine red Samian ware, and rarer black Samian, the high-class pottery of the time. We're inside somebody's house. I see what I take to be a bit of broken Victorian marble, or natural rock crystal. I pick it up, turn it over. It's yellow translucent glass, a beautiful colour in the morning light. I turn it over and my heart stops. It's inlaid with a trail of pattern, layers of white and opaque yellow. 'Is this anything, Walter?'

'Aye, it's a Roman armlet. I've had blue and green ones, but never yellow. This is rare, this is precious. It'll need to be recorded.'

I'm jumping up and down for joy, wellies taking me down deeper in the mud. A big hug for Walter. The fragment of armlet shines golden in the daylight, brightly coloured and crystalline as if somebody's glass bangle had just broken this minute, not 2,000 years ago. Who wore it, she, or he? Someone who lived inside the fort, not down at the glass-makers' quarters or out in the settlement. Someone who had the only yellow glass circlet among all the blue-green ones.

This chip of glass with double pot-hook inlay will go off to Birgitta Hoffman in Dublin, the European expert in Romano-British glass, to be recorded. We're moving gradually towards the fence. The heavy rain has turned up all new stuff, washed by a fresh shower, and the sun is shining on it. In the side of a large clod I'm staring at something I recognise from museums and from looking at Walter's collection. A bean-shaped Roman gaming-counter used in board games. When I was scriptwriter for the schools' TV series 'Caledonians and Romans' I wrote a scene for two child actors playing a board game. They were carried away by the game and by the argument at the end of it. They seemed to have been friends – and competitors – for ever, the Italian boy, Massimo, who played the Roman, *Falco,* and Matthew from Gala who was the Caledonian, *Don.*

Now the scene I visualised so often leaps out at me. I pick the glass counter up, it can't be... but it is. I call out, 'Walter, I've fffound aaa ...' I can't speak. The first to touch it. All those human hands before mine, moving it across the board, then the darkness of the ruins, the depth of earth, then working its way back up through the seasons of ploughing, to me. Nobody could appreciate it more than I do at this moment.

'Aye, ye've found a wee playing-man. They're quite common. No sae mony nowadays, though.'

It's Walter who has helped me to recognise what I'm looking at. Later, he tells everyone there are two big long scuff-marks in the field where I dug my heels in when he had to drag me away from the perfect day's fieldwalking.

Even if there's never another day, this is the one, the find-day of a lifetime. What I've learnt from Walter Elliot is that we're surrounded by differences in time and space. We don't just live in the present, we live in the past and in the future, we live at all times.

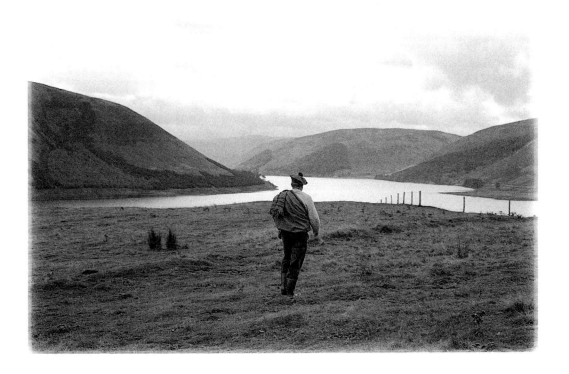

# Walter Elliot's Reel

As anyone who ever danced
      Hears both pipe and horn
Birl the pirn, his tractor overturns
      But Walter rolls up reborn.

He stays a good while in the field
      He often walks to search
For flints of chert, a chip, a glint
      Among the frosty earth.

And now he hears two rivers sing
      Their fervent radiant song.
Right by the water's edge he knows
      Sound carries them along.

Time past with present quarrelling
      Keeps separate in a huff:
Who was timberman and fencer
      Knows them well enough.

A Mesopotamia lies between
      The Ettrick and the Tweed.
At angular point, a sacred joint
      The horned confluence meets.

Flood suits the colour of the spate
      To brown or glowing white,
Two step the dance a hundred yards
      Before they will unite.

As arrowheads that needle by
      When fingers part the grass,
Or blade and spear which taper
      A point in time to pass,

So the sharp pace mixes rivers
      Reeling with tanged horn,
And birls the pirn. His tractor overturns,
      Walter rolls up reborn.

# The Lost Fogou

Up the narrow cleugh of Caddon Water
Cauld Face hill looks across at the cottage.
The door opens, *'Come away in, Walter,*
*I was doing the ironing but this is much better!'*
Switching off the iron, she leads us through,
Past boots hung on a peg by their laces
Past the collie hurling herself against the gate
And out onto grass that sounds hollow underfoot.

In the steep green side of Knowes Hill – you'll not
Find it on the map – there's a lintel at chest-level.
We look through a low entrance, a black opening
To a stonebuilt passage going in under the hill.
It has a niche on the left, for a crusie.
The passage, a metre high, cuts into bedrock.
Walter's grandfather lost a dog in here; further on,
He walled up the cave so he wouldn't lose another.

This hollow connects, beyond, with a creep,
With a chamber, with a secret man-made cave,
A Cornish fogou emerging in the Borders,
A bore-hole in a bone, dark, damp, fecund.
Here there are two nights, one behind the other,
Where we only see darkness, we can hear the night
Under it, coming straight out of the ground,
Hear its song coming all night long.

# Intaglio Ringstone

The hill is a globe, and the ploughland,
Well-washed by rainshowers, inswells
Its furrows. Whistling through a blow-hole, can
This be a sea-beast surfacing from where it dwells?

A small and perfect dolphin in the stone
Is leaping, with its tail up,
Smooth-skinned, cut into the two-tone
Slate-grey oval, to fit the sardonyx hump.

This good-luck charm goes as one integer
From the engraver's hand, it passes on
By a long-lost man the whole way to its finder.

The beaked dolphin makes its own impression:
It scribes the tides, calls and hears underwater,
Crosses seas and bears a man beyond.

NOTE: An intaglio is a gem with an incised carving. Here, the gemstone
is a sardonyx, with a sunk pattern of a dolphin, lost from a Roman ring
and found at Trimontium by Walter Elliot.

# The Sealstone of Caracalla

Rain and a light ray on the nailclip edge of red jasper,
The sealstone found in a field, the finger-mask returns,
My palm-pilot now, sticks to my skin and won't leave me.

You put the intaglio into my hand in the restaurant,
Among voices of the Romagna it morphs into his face.
A loyalty badge, it does his talking for him,

A pager reminding me who I'm lunching with today,
Scrolling through passport-size photos, whoever I want to call.
Two thousand year old stunner, a beauty, the only one

Taking a hold on minds. Rich bloody red
Too right for a tyrant, his hairstyle an Elvis quiff,
Caracalla was a real rocker in his designer cloak.

On a killing spree he murdered his brother Geta
In front of his mother. A crazy gambler with a passion
For the Blues *factio*, he bet on all the star charioteers.

This tiny likeness blows up into a gross icon
With the sense of his own status. It's the red clue,
The head crossing my hand, o intaglio hello,

Tell where you've been and who you know.
*I have been below the engraver's copper wheel*
*And the soldering torch where his hair smouldered.*

# The Farrier's Here

*rap tap, rap tap*

Tools with gripping faces
his tongs have jaws.
Heat begins to glare
from his portable forge.

A full kit of hammers
the file with teeth
nails with heads
the anvil has a beak.

50   In his sleeveless T-shirt
shoulders and arms free,
'Hold your hoof up,
don't lean on me!'

The nozzle of the bellows
puffs for the smith-god,
dogs chew hoof-parings,
the horse is hot-shod.

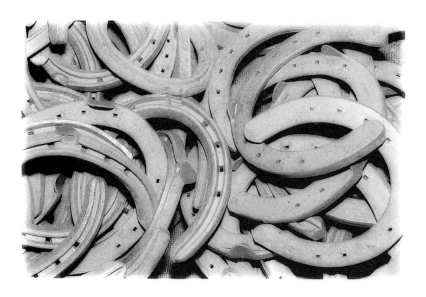

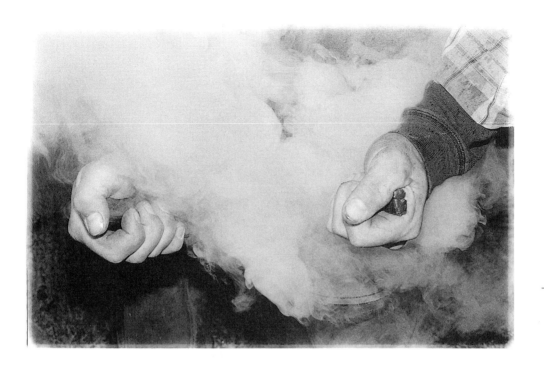

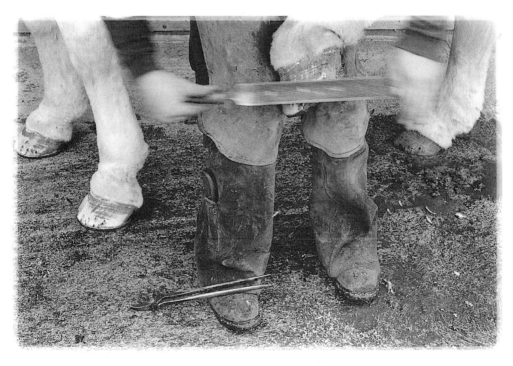

# Tom and Finn

*'And seven greyhounds on silver chains with a golden apple between each greyhound'* (from the Irish of *Táin Bó Fraích*)

whistle from the crag, crag whistle
    where he is resting on the ledge
        weathered as a detail on the cliff's face
           in his leaf-crown and his wolfskin cape
              rimrock nimrod –

and his lurcher, running cunning,
    with the turn of foot to be a hunting-dog,
        Tom only speaks to Finn in a whisper,
          he has his freedom night and day
            he's never on a leash –

the brindled creature of the otherworld –
    the touch of a hound pad on the path
        in the woods he passes through
          sinewy as the trees, long in the leg,
           what it is to be alive –

a shadow flowing across the open field
    and leaping the high-sparred gate
        over the dyke with one tap of a hind foot
          he's here so fast we don't see him
           till he's gazing at us –

eye to eye, with narrow muzzle and moustache
    one silver canine tooth in his white laugh,
        the roughcoat, longtail, swift swift swift,
          the setting sun lights him, spirit of the woods –
           the great hound turns to look at us in a wise way.

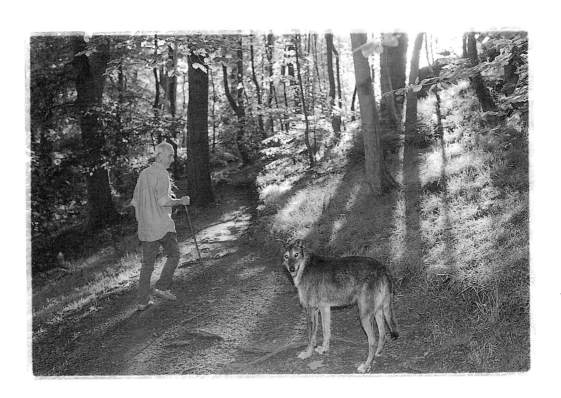

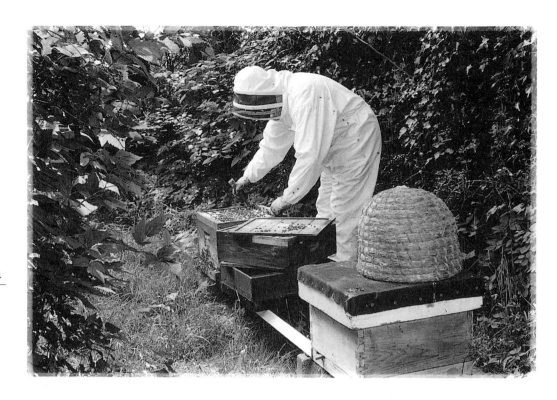

# The Lip

*from the Sicilian of Giovanni Meli*

Sae tell me, tell me, hinny-bee,
whaur ye're gaun at streek o'day?
Never a hicht ava
glowes roon us yet.

On the meedows aa the shakers o dew
trummle an skimmer;
mind ye dinna weet
your leengyie gowden weengs.

The wee flo'ers, droosy,
are fordoverit ower techt

inside their greenichy muilds,
hingin doon their heids.

But your weengie whidders on.
Ye flee an bizz wi' speed.
Sae tell me, tell me, hinny-bee,
whaur ye're gaun at streek o' day?

Is it hinnie ye're eftir? Gin it is,
steek your weengs, dinna trauchle yoursel,
Ah'll tell ye o a den
whaur ye'll aye can daidle an drink.

D'ye ken my dear lass,
my Nici wi' her bonnie e'en?
There's a flaur inside her lips
o a douce hinnie ye'll nae gae fae.

An gin ye kiss the rosie lip
o my dear luve,
thon mull o a smervie mou',
birl at it, birl at it.

There pleisur bigs
a byke for skeppie-bees
tae enteece, tae reive awa
ilka canny hert.

In aa the warld the hiving
will haud this day
tae kiss her mou'
my Nici's lippie-fou.

*Translated by Antonia Stott and Valerie Gillies*

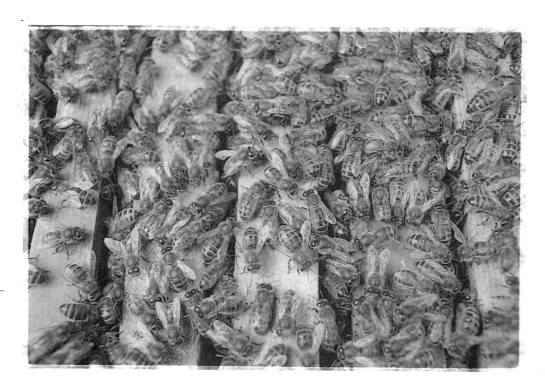

# Lu Labbru

Dimmi dimmi, apuzza nica,
Unni vai cussì matinu?
Nun cc'è cima chi arrussica
Di lu munti a nui vicinu.

Trema ancora, ancora luci
La rugiada 'ntra li prati;
Dun' accura nun ti arruci
L'ali d'oru dilicati!

Li ciuriddi durmigghiusi
'Ntra li virdi soi buttuni
Stannu ancora stritti e chiusi
Cu li testi a pinnuluni.

Ma l'aluzza s'affatica!
Ma tu voli e fai caminu!
Dimmi dimmi, apuzza nica,
Unni vai cussì matinu?

Cerchi meli? E s'iddu è chissu,
Chiudi l'ali e'un ti straccari;
Ti lu 'nsignu un locu fissu,
Unni ài sempri chi sucari.

Lu conusci lu miu amuri,
Nici mia di l'occhi beddi?
'Ntra ddi labbra cc'è un sapuri,
'Na ducizza chi mai speddi.

'Ntra lu labbru culuritu
Di lu caru amatu beni
Cc'è lu meli cchiù squisitu...
Suca, sucalu ca veni.

Dda cci misi lu piaciri
Lu so nidu 'ncilippatu.
Pri adiscari, pri rapiri
Ogni cori dilicatu.

A lu munnu' un si pò dari
Una sorti cchiu felici,
Chi vasari, chi sucari
Li labbruzzi a la mia Nici.

*Giovanni Meli*

# The Bantam-Man

See my top White Frizzle,
each feather curled, none grizzled.
And my gamecock with sharp spurs.
I like to keep all the colours,
the spangled and the brassies,
blues and buffs are my fancy.

Here's my handsome Black Pekin
with a green sheen on him
and my perfect Silver Sebright,
her feathers laced with light.
Then there's the true dwarf jaunty
short-stepping Scots Dumpies.

Yes, you can look
inside the broody's coop.
A puffball clutch
will hatch in this hutch
tiny atoms of fluff
but bantam chicks are tough.

At night they retire
inside close-mesh wire,
this henhouse can flummox
the greediest fox.
Chain-link in the roof
makes it predator-proof.

You see how I guard
the beauties of the backyard
with their long flowing plumes
their bright red rosecombs
their wattles and hackles
their tail-feather sickles.

Now leading the flock
is the poor man's peacock,

the best game bantam
who'll sit on your arm.
He flies into the trees
gives his four-note screech,

he's the dawn herald
with a high-pitched yell.
Just don't turn your back
if he flies to attack;
one thing about this cock,
he hates purple socks.

# Michael on the Cape of Stones

Michael is a tall manshape moving in the old caravan
where he stores the henfeed and the pellets for sheep,
blue eyes in a dark long head, herder of flocks of cloud,
calling me in at the roadside to say he's laying
again and there are fresh eggs. Tame sheep push by
and a cat with a deformed tail weaves round his feet.

By day, he lifts binoculars at the deepset windows
in every direction. His clean washing flaps on the line
in strong storms that bend the twin rowans
closer together and make the drystane dyke
need concrete at its base, he knows that's cheating.
A big wind blew the henhouse at his head:

he could have been killed but he's alive
for his eighty hens and three sheep and five cats
led in from the fields by Felix in black and white
to sit by the Rayburn sottering away hotly,
a row of his spotless green casseroles at the ready.
He scrubs flagstones below, each has its own face.

And here in his museum cabinet are the finds
he won in the fields, building the new house,
and this is the medal the hens found for him
scratching up Victoria's picture and cutty pipes.
He sits among pianos and harmonium and fiddles.
Upstairs are his newmade tongue-and-groove doors

and a carved balustrade with his binoculars
ready to see which farms are at their tea.
His hand on my shoulder, showing me far Duncroy.
He brings in bleached driftwood from a forest sea
and a pot of heather a woman would like.
Boulders for the new foundations he heaved by hand

but he never wears gloves, he hates gloves,
and I shake hands with feldspar and mica and quartz
when we say goodbye after companionship and work.
He returns to his house on the rocky bar of the outcrop
in the rain and the shrewd wind and the shifting light
where he glitters like the windgaa, the broken rainbow.

# Iain's Salmon

*Where does he stand?*

The gardens hang on a hillside,
daylight sways from his hands.
Salmon shiver in their cylinders of scale,
their silver will brush his side.
The spotted dog waves her tail,
she hears the barking of the stone whippet.

*What does he see?*

Farther to the south, the meteorite
falls on the shinty field. Flecked tweed.
Sky-high hills on the horizon
gather lochs like papers on a spike.
Salmon leap in his thoughts,
his fingers hook their rose gills.

*How does he leave?*

Look in his eyes and see the river
he fishes with glass boat and midnight torch.
Salmon return to the pools of his eyes.
The stone dog prances on Eileanreach hill.
A moustache escapes to become two dolphins,
the ocean of being is lapping against his body.

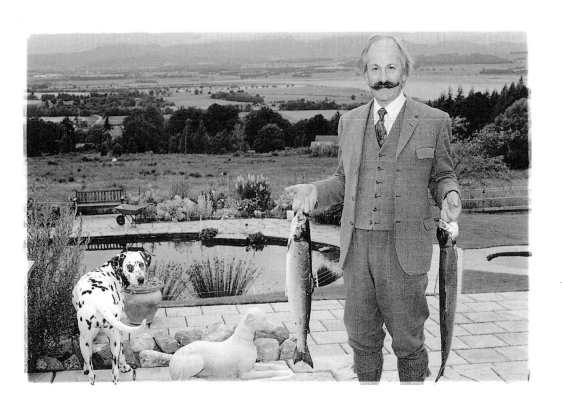

# Surfer

'A bright Sunday but there's no warmth in the sun. The light is almost blue, I feel glad it's not grey. Jason in January surfing, that's the shot. Days before, semi-submerged in my bath, I decided on a half over- half under-water shot. I had gone to see my friend Joe asking after water-proof cameras. Joe lent me his one, a brand new shiny yellow submarine Canon. Jason was bringing a wetsuit, which posed the most problems. Teenage years never really leave a girl even after the puppy-fat has fallen away. I had been told to wear a swimsuit so we could change into wet-suits in the back of the car. I only have one and it's a strappy starlet leopard print number. Wishing I'd seen the sense of a speedo cossie, I buzz Jason's door.

The Volvo full of boy and board, we go to get Sam and Kathryn. They load up and we set off in convoy, chasing waves. Driving down the coast, Jason breaks off mid-sentence, nose pressed to the window, his first glimpse of the sea. A decision is made: we head off-road and arrive at the edge of a golf course. Worse than changing into a wetsuit is trying not to watch other folk doing it. All suited up in rubber, we weave a way by the course to the cliffs. My foot finds a hole and I fall like timber. The golfers laugh, Jason and Kathryn laugh, and Sam is uncontrollable. I'm accepted. Subsequently Sam finds it difficult to look at me without smirking and retelling the felling. They test the water, they are not pleased, we must move on. Travelling the coast again, down the AI in a wetsuit, with a man in a wetsuit beside me, I wonder if it's a stoppable offence. I think about asking Jason but he has become less chatty, he is a merman and he must get to the sea.

At White Sands the waves are too whippy. We discuss the sea through car windows and follow the coast to Pease Bay. We stop before the descent and look down, the little square caravan roofs in the winter light look like a faded picture postcard. The waves are good, they roll well, but there are the black dots of other surfers in the water. Jason counts them, it's not too crowded. In the car park other waterboys are changing at the back of campers. Jason and Sam know most of them and they speak together in salty tongues through chattering teeth. We walk between the caravans to the beach. The sea greets us and I gasp in the cold air.

It all happens very quickly. When they hit the sand they run while girl with camera walks into the sea. The first wave is between me and the

boys, Jason shouts over the noisy froth for me to dive through it. 'Now', but I miss it. I hit it too late, the water holds on to me, lifting me up and back in a curl, my head meets the sand floor and I think to breathe – 'Now', but I miss it. The wave still has me and it drags me back to rejoin the sea. I breathe in salt water. Standing up is difficult, the water trips me, flipping my fins over. Briefly I manage to stand upright in the pull of the waves and look to Jason, he stands easily, knowing everything about these waters. He counts me in to the next opportunity, again the sea closes on me and I can't get through. Jason and Sam wait on the other side of the wave. It feels futile. 'Val, what next?' I shout in my mind in the direction of the hills, but Val is busy, I find out later that at this moment she is stopping a runaway horse and returning it to its owners. I am holding the bodyboarders back, so I wave them on and lift the camera to capture them before they become black smudges in the white. It won't work. The underwater photographer can't get under the water and the waterproof camera is leaking. I watch them riding the waves, in control, meeting the challenge, deep in the sea.

I turn back to shore. Kathryn sits looking out, thinking about her PhD in Marine Bio-Technology. The hammering has made me weary and I haven't got the shot. I towel down the leaky camera and put it away. Beaten, I walk back to the waves and give in to the strength of the sea. The weariness leaves me and I feel like I did when I was small in the sea, scared and excited, cold and wet and free.

Nostalgia fades. I'm still cold and wet, while wrapped-up dog-walkers are looking at me. Jason and Sam are surfing still, they will stay in the water till the light fails.

A few weeks later I return to Pease Bay and get the shot. This time I remain on terra firma and photograph Jason on the sand. He twitches, turning to look at the sea. Through my lens his sea-blue eyes plead with me to let him go. I am holding him back from the surf, so I wave him on.'

*Rebecca*

# Surf-Speak

You want to be there to catch the wave
      living breathing surf till it sounds in your dreams

you want to get where it peaks, energy beneath the board
      rolls in the line-up of breakers and just keeps going

you want to be on the wave face at the plummeting lip
      if you fall off a big one you're going to get eaten up

*aaayyye... see ya out there, aye*

you know it's going to be good with an offshore wind
      perfect waves peeling all the way along the reef

you feel the force of everything that made that wave
      winds across the sea and the pulse of storms

you're in there timing sets of three, assessing rips
      pulling into a barrel, that's where the power is

*aaayyye... always thinkin', always lookin'*

to be inside a wave, there's nothing like it
      to get that deep, not getting touched at all

the foam is chasing you along as it breaks behind
      you ride it to the end, then you go and get another one

to be there when wind, tide, swell all happen at once
      as the first seas and oceans beat inside you

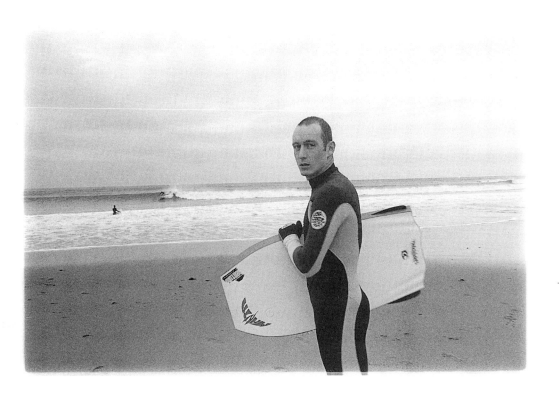

# The Lioness and her Men

In January 1997, ferryman Rab Graham, looking out for stones that might snag his boat, was the first to spot a stone eye peering out from the mud of the River Almond. He soon realised that this was not a discarded piece of garden statuary. Crowds of onlookers gathered on a bitterly cold day to watch archaeologists dig a Roman lioness out of the river-silts in which she'd been immersed for 1,800 years, till tidal changes revealed her.

For everyone present on that wintry evening, it was the first time she'd emerged into the light, the first time human beings had seen her for millennia, and they wanted to be there. A cheer of delight went up from the crowd. To city archaeologist Mark Collard, this was 'the find of my career.' He couldn't bear to watch the final lift as she was swung onto a waiting lorry, but had to take a short walk while that was happening. 'Not a crack, not a scratch,' he said afterwards.

For Fraser Hunter, curator of the Roman collection in the National Museum of Scotland, she was the best thing he'd seen in his career too. 'The muscle structure of the back and even the dewclaw of the lioness can be clearly seen. This is the kind of thing you dream about as an archaeologist. I feel immensely privileged to be working on this amazing beast.' She is in Fraser's care in the museum now, where he looks at her fondly and declares, 'You can almost feel the lioness's breath on your shoulder.'

Visitors can see a strange Romano-Celtic sculpture, a lioness eating a man, holding his head in her mouth and his upper torso in her paws. She is lion-long, a life-sized 5ft of white desert sandstone with two serpents writhing along on the plinth. Anyone who saw her on that first afternoon at Cramond would have a shock to see her emerge sandy-white after months of cleaning.

Theo Skinner the conservator was always hopeful that he would have a good result once the lioness was cleaned in her desalination bath and rejoined to her plinth. He supervised her throughout months of washing in de-ionised water to remove the salt. Several more months followed when she was kept damp to prevent her drying out too quickly.

Not many people know that the archaeologists who jumped into the river that winter afternoon and baled out, digging the lioness free in the few hours before the tide flowed in again, were all unwell with various illnesses afterwards. They had just leapt in there, they were so keen to

excavate, but the River Almond is one of the most polluted streams in Scotland. The lioness herself was stained a muddy reddish-brown colour by iron-washings upstream, and waterlogged by tidal salts.

It was the summer of 1998 by the time she was ready to be exhibited, and Mark Collard commissioned me to write a poem to welcome the lioness to Edinburgh which would accompany her to the City Art Centre where she would be displayed during the Festival. For the first time I was writing about a media star who had featured in *Hello!* magazine.

I saw her in the NMS hangar at Granton when she was having a bath. Roman experts think she resembles other Mediterranean man-eaters, but she is unique in Britain, because she is a lioness, and because her prey is human. Her serpent companions are unusual, too. Her Roman viewers would have recognised that the snakes symbolised rebirth. They are regenerative because they shed their skins and live on. But the lioness is not a purely classical piece, she has Celtic elements too.

One classical expert deemed her to be highly exaggerated and stylised. Meeting the lioness, I thought her very lifelike. Perhaps her teeth are dragonesque, but she recalled for me how Marcus Aurelius admired 'the grinning jaws of real lions' and 'the wrinkling skin when a lion scowls.' The Romans were struck by things of this kind in nature and admired the sculptor who could imitate them. I hoped to show what was realistic about this lioness in whatever I would write about her.

Naturalistic or not? The question led me to visit two men linked to the lioness, each in his own way, both of whom made a number of observations that contribute to our understanding of her.

A showery autumn day at Cramond, and Rebecca with her camera is on board ferryman Rab's boat. I'm standing on the slippery slipway chatting to him. The metal gangplank between the boat and the muddy shore hovers beyond the gaping hole left by the excavation, a lion-shape stamped in the mudbank at low tide. Handsome and distinctly Roman in profile, Rab became ferryman ten years ago on this, the only man-powered ferry left in Europe. He uses an oar like a rudder to scull across, and he's interested when I tell him about the Roman steering oar in the museum. Although he was rewarded with £50,000 under treasure trove law for finding the lioness, the money doesn't matter to him so much as the thrill of discovering such a beautiful and ancient sculpture. 'It's the fact I found it. I have always been interested in history. I prefer the past to the future.' He looks everyday for another lion, hopes the

river will be in spate, needing another storm to throw it up. He's wondering about the new underwater excavation; 'They've got it all sewn up, so I can't find another lion myself.'

He ferries Rebecca across to the old jetty. He'd seen us, spoken to us from the front door of his cottage on the other shore. Often people call him to get over. 'They stand, I stand, looking at each other,' he says. 'They wave, I nod, like this. Others will do handstands or cartwheels, letting me know they want to cross!'

The lioness was found with a single coin, to pay the ferryman. In the classical story, the ferryman would take each soul across the River Styx to the other world, and the dead were provided with a coin as their fare. Through medieval times people visualized this crossing to the afterlife, and at the beginning of the Renaissance Dante describes the souls gathering on the shore to be ferried across by the ferryman known as Charon. I've translated his lines from the Italian in Canto 3 of *Inferno*, where Charon speaks to the souls:

'Never hope to see the heavens again, let go your hold!
    I'm coming to take you to the other shore,
    into eternal darkness, into heat and cold...'

But those souls, the weary naked wraiths,
    changed colour and their teeth chittered
    as they understood Charon's speech, cruel and grave.

They blasted God, cursed their parents with an oath,
    damned all humankind, the time, the place,
    the seed of their conception and their birth.

Then they all huddled together to whine,
    moaning loudly on the evil coast
    which waits for everyone who has no God in mind.

Charon the demon, with his eyes of burning coals,
    beckoning to them, gathers them all in,
    and any who linger, he batters with his oar...

So they go off across the black water:
    before they've disembarked upon the other side,
    a fresh crowd on this margin has begun to gather.

Ferrymen could be bossy, they would need to be. I ask Rab, 'Do you have to keep people in order on the boat anytime, are there any you won't take on board?'

'There are some people who like to be in control,' he answers, 'they don't think I'm in charge, they won't sit down, they keep standing up in the boat, then when we reach the far side they lean over and lurch about and reach for the jetty. I've got it down to a T, I spin it a little so that they have to sit down suddenly!'

# The Ferryman Who Found the Lioness

Tide's out. Swans land on lenses of water and silt
alongside the *Energeia* and the *Phantom*.
Rab sculls, steers with an oar for a rudder,
ferries you across dark waters to the other shore.
Every day he's looking for a lion, he needs
another storm, it was a storm threw up that one
an inch from the base of the ferry steps. He saw her
lion face lift above the mud. Crisp toolmarks.

A lioness takes a bite from the head of a man.
The crane swung her up, a bringing into light,
one coin of Hadrian lay below. Salt on Roman lips.
In the wintry sun, Rab runs out his gangplank of silver.
If you're crossing from the old jetty to the farther shore,
the coin under your tongue is for the ferryman.

We may see plenty of lion-hunts on TV these days, but unlike the Romans, who emptied Mesopotamia of lions to fill their arenas, we have not necessarily seen a lion gripping a man. Would she hold her human prey by the head like that? Who knows about lions, I wondered. The Keeper of Carnivores at the Zoo, of course. When I wrote to John Hanning, he phoned straight away, 'Come up and see my cats.'

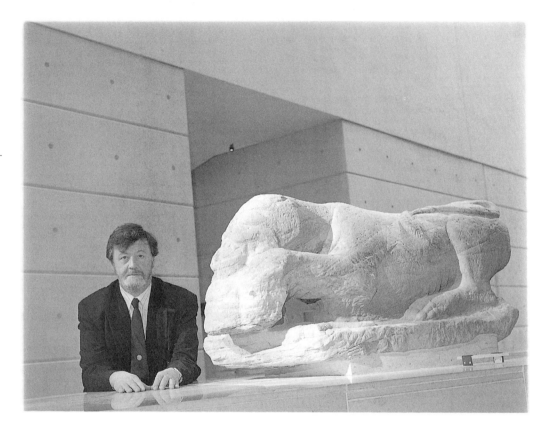

Across the hollow ravine they hear John's voice and raise their heads from sleep. Around the back of the rocks he calls them in like domestic moggies, rattling his keys. Double, treble doors, the shutters open. We are in the feeding area for the lion and lioness. I am seeing them close up. They are huge. Through the single bars and the raking gap below, their great paws pace with sheathed claws. The black-maned lion is long as a three-seater sofa, holding his face up for John to rub his jaws, his rounded ears. He likes his whiskers scratched.

The lioness enters close on his heels and looks me in the eye. It's hard to return her look and live in that yellow blaze. She curls her lip. She's listening to me speak, tuning in to any voice-notes that would signal fear. I smell her, I feel her warmth. My heartbeats resound in what I'm saying. Quiet, I keep the fear down. She inclines her head to John, pays him attention. She swings her long loin around on a quick turn, her powerful tufted tail held up, her belly rippling with its row of teats. Her cubs are young lions now. Wandering off, she resembles a long sandy-coloured desert ridge. She has found a calm in me I didn't know I had. It's something I've learned about myself, in the presence of a great animal.

John talks of his lions in his husky voice. Yes, he has been gripped in those jaws himself, once, though not by the lion, but by his favourite, the leopard. The time his own hand-reared leopard went for him, it must have got two or three swipes in at him before he lifted an arm to protect himself and felt the blood gush from his head. He saw him coming, leaping straight at him from the front, but he was looking to see if someone had left the shutters open at the side. His first thought was for his leopard, if he got out he would attack somebody and be shot dead. He gripped the leopard by the muzzle and pushed him back in. When it was over, he was in complete shock, finding he was still alive. And calm. After his wounds were treated, he went back up to the enclosure to see his leopard, and he came straight up to him for a pat, as if nothing had happened.

Yes, John is very impressed by the Roman lioness, she puts him in mind of his old lioness who was strong enough to bring down a bull buffalo on her own. She was so big she could have taken a kick from a zebra and gone on after it. Like the Roman lioness, she could kill with a single puncture wound through the skull. Yes, she will get up on the back of her prey and keep pressing and biting down, she will hold it like that.

He thinks the tail of the stone lioness is very realistic, there's lots of tail movement there when a young lioness holds her meat; the tail in close like that means she's being possessive about what she's got.

Later, we meet in the museum, where John is looking at the Roman lioness. He admires the feathering of her tail hairs and the massive paws with strong, curved claws. He spreads his own great hands alongside, which have handled lion and leopard and panther and puma for 28 years and they are the same size. Live lion-keeper, stone lioness.

The Romano-Celtic people who saw her first would have read the sculpture immediately. As the lion-keeper says, 'It comes to us all', which is precisely the Latin, 'ad unum omnes'. The human head is a *memento mori,* we are confronting our mortality. The lioness shows the power of death. The snakes indicate the survival of the spirit. This was part of a monument of magnificence. She's rather like a poster of a SITEGUARD lion at the entrance to one of today's construction sites. She says, 'Watch out.' She's there to frighten off any predators who might come about the burial place. Fantastic, nightmarish but also realistic, she was a powerful object, probably placed in the river on purpose, either by the Romans as they retreated or by the native tribes as a votive offering.

But her absence from the world and her reappearance today may hold meaning for everyone, when each of us tries to make sense of what happens to us. Ultimately, it's not about a lioness eating a man, it's about the spirit. The lioness is both protector and devourer. The bearded man in her jaws, in heroic nudity, may be dead already but remains open-eyed, stoic, serene through all vicissitudes. The snakes who shed their skins slither out and away to a new life.

Writing poems to welcome the lioness, I was testing all these ideas out, in the space of a few days, receiving the shock of a cancer diagnosis and undergoing a major operation. The lioness was getting very close, her paws were on my shoulders, her breath huffed the hair on my head. Composing a poem with full leonine rhymes, I needed the experience of the past to get through today. When the lioness came up suddenly and silently, I could recognise my feelings of horror and of betrayal by my body. I realized that it might be possible to stay calm, while part of me was preparing to meet death. Strangely, the lioness imparted some of her strength instead. She breathed in my face and brought me alive.

# Cramond Lioness

*for Leaena*
*the Roman lioness*
*from the River Almond*

how close she comes devouring
a man in her jaws
but like a sphinx protecting
the one in her forepaws

River Almond roars in spate
the wave on the curl
the wrinkled leonine grin
rolls back in a snarl

the stains that mark the lioness
no river can wash away
spattered with iron-ore
the man-eater hunts today

stirred up from the tidal pool
life and death together
sweep along neck and neck
with these two on their tether

the lions no longer wander
in the rising human tide
and we are the losers –
how many will survive?

she was given with a wish
it strikes to repercuss
we took her from the river –
where does that place us?

# A Welcome to the Lioness

She's here. A lioness is swimming in the tide
among mudbanks shifting close to the quayside.
Some say the moon made lions out of sea foam;
the man with this one doesn't speak against the sun.

She comes up silently behind him. In a rush
she explodes onto his back, blood starts to gush
from two-three swipes she gets in before the kill
with a puncture wound right through the skull.

And now the strength, the power of paws
laid over his shoulders, with those razor claws
curved in to hold him tight, like it's a place
where he could die with a smile on his face.

His brow wreathed with a crown of fangs,
two brooches are pinned to his upper arms,
her lion-head is his helmet, and her hide
becomes his cloak turned out on the rough side.

A lioness has got up on his back.
The hair on his head and beard crackles
and rises when her hot breath huffs.
She is tapping her flank with her tail-tuft.

Two snakes, like the coming and going of spring,
swim the river. Swifter than lions, they're lightning.
A dusty snakeskin floats on the surface, sways
where a gleaming viper glides rapidly away.

Man and lioness, two predators, fall
from a world so distant it hardly exists at all.
Thrown into a deepwater channel together,
the couple vanish off the face of the earth.

Her roar's pressure penetrates
the estuary shore, the wooded shades.
Their two heads are going down to drown,
while both look outwards, hearing sound

trapped in the river's singing flow
a man's voice from two thousand years ago,
*If I must die in this cold place*
*I want lions to guard my space.*

The ditch, the workshop and the granary,
the bathhouse and the ramparts, where are they?
Nightly she paces, pugmarks on this floor.
The lioness is roaring on the shore.

Here are two who were meant to sink
newly revealed from the lustral springs.
White desert sandstone reddened with his blood
more bright than ever rises from the flood.

# Beasts

I welcome all the creatures of the world with grace.
Hildegarde of Bingen (1098 – 1179)

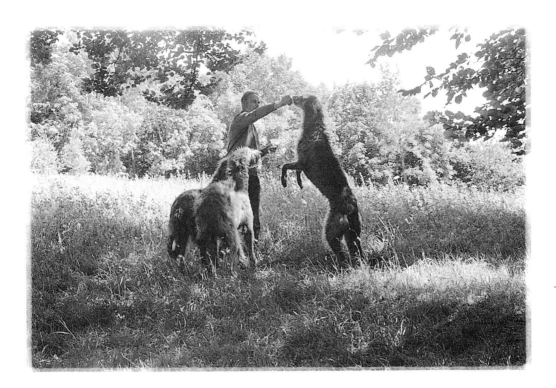

# A Deerhound Day

We're soaring southwards out of Edinburgh, in a powerful GTI, Rebecca and camera and whippets in the back. Ask the exile or the Scot who lives in the city, 'What's Scotland like?' and they'll give the same answer. Visualise the great spaces of a Highland moor, rough hills on the horizon, intense clean cold air. Journey through the pass and take the long road up the glen, turn in at the stand of Scots pines, to the white lodge. There's a fireside with people gathered round it in warmth and friendliness, and getting up to greet you, a couple of tall grey deerhounds, as rough-coated as their native hills.

We're travelling towards a source of that picture today, a source that begins in the southern uplands where our friend Hilda Robertson rears her deerhound puppies with great success. Our way lies alongside the

Pentlands, where Robert Louis Stevenson wandered and learnt the lore and the speech of the hills with the Swanston shepherd. Over a hundred years later the intrusive roar of the bypass and the march of the disfiguring pylons seem out of proportion on the gentle slopes. Soon the city is out of sight and the open road is my cue to whistle the tune, *The High Road to Linton*, from my favourite rendition by Savourna Stevenson and Aly Bain.

We follow the carrying stream of the tune, looking out on our left over the Moorfoots and Lammermuirs, and way ahead, to the perfect curving forms of the Southern Uplands. It's a great travelling tune, and this is the very road on which it was composed. How the harp and the fiddle whirl it along, they can fairly *ca the pirn*!

In Biggar the broad main street that saw centuries of use as a market place is thunderous with heavy traffic. We turn uphill at the cadger's brig, taking the rise to travel the roads of Lanarkshire, the red roads of my girlhood. Now the council uses ordinary grey tarmac, but the under-colour of red shows through in places, a tone that blends better with the earth of neighbouring fields.

And this was my childhood road, the one we used to take in the old black Wolseley, heading home to the house on the moors, with our oat-meal and flour and a Saturday sweetie from the grocer's in Biggar. As we drove along I'd roll down the window to look out at the cottage in a hollow of the hills, tucked away in a neuk by a running stream. Its name, *The Swaire*, describes it perfectly, coming from the Old Norse *sviri,* a neck, showing us a declivity between the hills, frequently one with a road. It lies below the height of Bizzyberry Hill, where the 'berry' element is also Old Norse from *berg*, a rock. Here the rolling slopes hide a sheltered spot, just the place to be a nursery for young deerhounds.

The deerhounds are such natural creatures that they can be reluctant to breed in the modern world, just as cheetahs are not inclined to mate in zoos. Yet they are happy enough in this kennel for there to be two big litters this summer, fifteen puppies all booked by would-be owners, as far-off as France.

In the valley of the Biggar Burn, *The Swaire* is tucked into the slope of its own green field that rises steeply to the little wood of native trees on its crest. Deerhounds love to run uphill, where their long backs give

them the advantage. On a misty morning when vapour ebbs and flows on the shore of the hill like waves, as the great grey shapes of the deerhounds step out against a backdrop of Scots pines, your heart lifts to see their grace and dignity. They are magnificent. It's a strongly atavistic sight, one our ancestors must have enjoyed. Here's a song handed down in the Borders, one I've never seen written, only heard.

> Well, Johnnie awoke of a May mornin,
> Cried for water tae wash his hands,
> 'Gae lowse tae me my twa grey dugs
> That ligg bound in iron bands, bands,
> That ligg bound in iron bands.'
>
> When Johnnie's mither she heard o' this,
> Her hands for dule she wrang,
> Sayin, 'Johnnie, for your venison,
> Tae the green-wud dinna gang, gang,
> Tae the green-wud dinna gang.'
>
> But Johnnie has taken his gude benbow
> His arrows one by one,
> An he has tae the green-wud gane
> Tae ding the dun deer doon, doon,
> Tae ding the dun deer doon.
>
> Johnnie shot, and the dun deer lap,
> An he's wownded her in the syde,
> An atween the water an' the wud,
> The grey dugs laid her dry, dry,
> The grey dugs laid her dry.

(traditional)

Immediately after the chase, Johnnie is set upon by seven foresters, and though he 'kill'd them aa but ane, ane,' he dies, leaning his back against an oak tree, and 'his twa grey dugs are slain, slain.' The possession of such high status dogs for following the deer would draw unwelcome attention.

Johnnie from the Borders would have recognised the great medieval deer drives pursued in the Highlands too, the *tainchal* of the Lords of the Isles, for example, where herds were moved off the mountain through a narrower glen. Here huntsmen lay in wait, ready to slip their hounds

after the red deer. To follow them, the hounds had to gallop on the rough, over moorland and bog or up the steep glen slopes. Johnnie would also recognise the work of the dogs in recent years, when hill-farmers suffering damage from roe deer would shoot them, but second snap-shots at deer in woods are rarely successful, so the deerhounds were invited in to follow any injured animal efficiently.

The deerhound became scarce after the Jacobite Rebellion of 1745, when every characteristic of Highland life was suppressed. By the early 19th century, Archibald MacNeil of Colonsay thought there were only about a dozen pure bred deerhounds left in Scotland. He and his brother collected all they could find. In a letter, Lord Colonsay talks of pursuing the wild red deer, saying, 'No gun was ever taken to the hill – the whole done by the dogs.'

The breed owes its survival into the 21st century to a few enthusiasts, especially Anastasia Noble of Ardkinglass, whose breeding programme began in the 1930s, and who attended shows and coursing meetings into her eighties. She is one of the few owners who can remember deerhunts. So too is Kenneth Cassels, talking here about taking his young hound Kirsty out with Murdo, a stalker on a West coast deer forest in the 1950s.

'…suddenly the hind was on her feet – one startled glance and away. I was not conscious of slipping Kirsty but there she was streaking across the heather in that deceptively leisurely deerhound gallop in which each stride is some eighteen feet or so. Murdo had brought Kirsty and me in from above as he would for a rifle, which was a tactical error for a hound; hounds being lighter than the deer are better slipped uphill. Placed as we were the hind had no choice but to go down and down she went over a very rocky and precipitous slope at a speed I would not have thought possible. She had a sixty yard start at the top but by the time she came out to the undulating floor of the glen she had increased this to some three hundred yards.

Murdo was clearly disappointed and more or less prepared to write deerhounds off there and then. Fortunately the glen was long and wide and quite open so that from half way up one side we had a clear view. Once Kirsty was out of the rocks she really set down to gallop. She began to pull up on her quarry as if there were an elastic band stretched between them. It was at this stage that Murdo's English deserted him

and he began exclaiming in Gaelic in his excitement. Rapidly the distance closed. Through my glasses I saw Kirsty range up alongside, gallop for perhaps 20 yards level with the hind's shoulder and then suddenly make her leap. There was a wild flurry of movement as the two animals cartwheeled through the air and it was all over... On examination there was no mark on the hind at all except the one terrific bite behind the head and the utterly broken neck. 'The jaws she must have!' said Murdo.'

(Kenneth Cassels, *The Most Perfect Creature of Heaven*)

Cave paintings in Asia, some dating from around 6000 BC, show us the hunting dogs of our ancestors, which look like the gazehounds of today, the hounds which hunt by sight. The deerhound has developed as the Scottish version of these breeds, resembling a rough-coated greyhound but larger in size.

It was common throughout early Celtic Britain, as we can see from archaeological finds such as the bronze figure of a deerhound discovered at the shrine of the healing-god, Nodens, in Lydney, overlooking the river Severn in Gloucestershire, dating from the third century AD. The presence of the hunting-dog in his sanctuary is important. The Celts seemed to make an enigmatic link between hunting and healing, between the pursuit of prey and regeneration, the taking and the giving of life.

After the Red Deer (Scotland) Act was passed, it became illegal to use a dog to take deer (unless wounded). Although vast areas of the Highlands are overpopulated by deer, the paradox is that the deerhound's real work has gone. Man's earliest companion, who ensured his survival over thousands of years, has been supplanted by the introduction of the modern rifle. Now it is the show ring that keeps the breed alive.

Hilda runs a most successful deerhound kennel at her long cottage, with its big woodshed and spotlessly clean accommodation for the hounds on its east side. Above it stands the rocky knoll of Bizzyberry Hill, with the stones of an ancient fort on its summit, and another early Bronze Age enclosure on the saddle. When the deerhounds bark to signal our arrival, their deep 'Bow Wow' resounds from the hill where their forerunners may have leapt the rock-cut ditch or spent the night on the earth floor with the dogboy curled up asleep beside them.

Hilda, weatherbeaten and slim with keen blue eyes, is busy preparing a

box for the puppy who is to fly to Paris in the morning. In the afternoons she works as veterinary nurse in the surgery in Biggar. At home with her deerhound kennel, she always seems to be able to help each puppy to survive through whelping time.

Derrick is here too, learning the lore of the hounds from Hilda. His own Bob travels everywhere with him, and a fine upstanding dog he is. Derrick's daughter, Claire, is on a winning streak as a handler at the dog-shows. She won first prize exhibiting Hilda's young Skerry (Tartraven Lyra Skerry) at Crufts last year. Derrick likes to help with the care of the puppies and with all the preparation for the show-ring. The number of entries for the Breed Show for the year 2000 in Scotland is upwards of 200 hounds.

We leave the whippets in the car, they're watching to see when the deerhounds will come out to play. Hilda invites us in for coffee. In the doorway Rebecca gives a surprised cry – not of fear but of astonishment – at the great size of the hounds. They are enormous! It's quite something, to meet three of them at once, in their own porch. But they are so gentle and loving towards human beings, they are wonderful to live with, and never aggressive. Their thick dark blue-grey coats are rough and crisp to the touch. Their eyes are hazel, with black rims that shine as if with eye-liner. They have a far-off look, for watching horizons. Their small, folded ears are soft as lamb's ears. Narrow, aerodynamic heads display dignified profiles, impossibly long noses and silky moustaches.

They're magnificent. Bigger than greyhounds, they are long and light with straight forelegs, deep chests, neatly knuckled feet, and long curving tails they use to steer themselves by at the gallop. When we sit in by the ingle-neuk, below the wooden lintel, Hilda says, 'It's wall-to-wall deerhounds in here!' They take up a generous space when three of them stretch out on the floor.

These adults stay indoors while we go to play with the puppies. This year's pups are friendly and outgoing, a mix of iron-grey and brindle coats with happy hound faces. Running free on the way to the field, they are *with* us in the way that hounds love to be with human beings from day one, obedient because they're so eager to please. They bounce around and practise chasing each other.

They're so inquisitive, it's hard to get far enough away from them to take their pictures, so Rebecca goes up ahead, through the long grass of

the field, to the top of the slope. Here she waits, couched with her camera near the wood. The pups rush uphill and arrive to greet her with terrific enthusiasm and joy. From the ground Rebecca takes shots of them sporting and playing with one another.

Then two full-grown hounds, Bob and Skerry, arrive, full of energy, in their element. And this is what they're like every morning! They look like wild rolling rainclouds with a spark travelling between them.

# Electric Deerhounds

Two deerhounds play in the field, they wire
it up themselves. Volts jump across the air
between them. They're plugged in to Bizzyberry Hill,
currents flow through the filaments of their hair.
Tungsten coats. Animal magnetism. They thrill,
the visible charge. Creatures of heaven, they fill the eye.

92

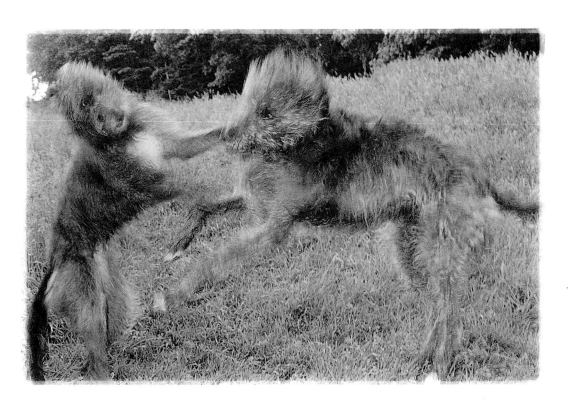

Rebecca is covered in muddy pawmarks. Hilda offers her a giant T-shirt to go home in; Claire and Skerry won it, along with a supply of dogfood, at a show. It's huge on Rebecca, unlike the tight tops she usually wears!

Hilda has made us lunch, and we enjoy a glass of white wine and chat about Sir Walter Scott and his deerhounds. Among Hilda's hounds, the good-looking Vinna has been photographed so often she sidles out of the way if she sees a camera, just like Sir Walter's Maida, who'd been painted so often he'd get up and leave the room whenever he saw brushes and a palette. Scott was always surrounded by his dogs and Maida was the most famous. 'I got him from Glengarry,' says Scott. He means from the chieftain Glengarry, not the place. He named the hound after the battle of Maida where his friend Sir David Stewart of Garth had been the hero of the hour. It is Maida who is carved beside him in the Scott monument. 'He is I think the finest dog I ever saw,' said his fond master. When the king commanded Scott to sit for Sir Thomas Lawrence, Scott said he 'wanted to have in Maida that there may be one handsome fellow in the party.' The iron-grey staghound sat for Nasmyth as a figure for the foreground of a landscape, and was again painted, to Scott's satisfaction, by Sir David Wilkie the following year.

Washington Irving gave an account of Scott and his dogs, noting that Maida had given him a 'courteous reception'. Maida is the prototype of the fictional Roswal, in *The Talisman*, who defends his master Kenneth while he is crusading in the Holy Land. Roswal is described as 'A most perfect creature of heaven... of the noblest northern breed... deep in the chest, strong in the stern, black colour, & brindled on chest and legs, not spotted with white, but just shaded into grey – strength to pull down a bull – swiftness to catch an antelope.'

Macpherson of Cluny gave Scott another deerhound, named after the most famous of all, Bran the hound who belonged to the hero Fionn. This Bran lay yawning at Scott's feet while he was working on yet another novel.

Scott loved coursing with his dogs, and while he was at Abbotsford held two meetings a year which brought the whole countryside together. He knew the breed well, as we can hear in his lines from *Davie Gellatly's Song to the Deerhounds*:

Hie to haunts right seldom seen,
Lovely, lonesome, cool and green,
Over bank and over brae,
Hie away, hie away.

These are lines to remember the next time we see deerhounds patiently waiting to enter the show-ring. It's in the open that the breed is seen at its best, trotting at 10mph then ramping forward in great bounds to a loping canter in which each stride would carry it the length of most suburban gardens. It's in the open that the deerhound can accelerate to tremendous speed while running uphill. That's the place for these dogs who reach a height of 30" – 32" at the withers, and weigh in from 85 – 100lbs in running trim. About the same as one of my teenagers!

The oldest legends of its origin tell us that the hound is the gift of the land herself. In this traditional story from Callart, *Na Gruagaichean*, two mountains give a hound to a deer hunter. After the death of the old hunter, the hound returns to the mountains, but a waterfall and a cave in the region are known by the hound's name. It's a story to do with origins and the naming of places.

In Callart there once was a man who was a well-known deer hunter. He had a hound who, like his master, was growing old and losing his speed. One spring day, the hunter set off with his old hound to follow the deer. It was a morning that might have made anyone happy. White mists rolled off the glen, revealing the rusing river and, higher up, crags and hollows and far above these, the high peaks. The hunter knew that deer would be found in the corries up there.

He began the ascent. Exhausted by scaling the first range of green and low hills, he and his old hound rested by a waterfall where plumes of spray rose like smoke and floated away on the morning wind.

The old hunter had spent his life climbing these hills, and he was hardy, but not so strong as he once was. His way lay straight upwards. By the time he'd climbed the first steep, his eyes were sunken, an icy chill shot through his legs, and his head was giddy. Above him hung the high snow cornices, and he could hear the cracking and creaking of ice like eerie voices.

He began climbing up again, until he reached the corries where the deer browsed. Although he saw herd after herd of them, and followed them cunningly all day, he didn't get near enough to slip the dog after them. He wandered on till the sun was setting. Suddenly he saw a fine full-grown stag on his own, and he set the hound going after him. The hound stretched himself with all his strength, and at first he seemed to be gaining on the stag. Then the hound began to fall behind. In no time, they'd lost sight of the stag altogether. The hunter sank down, and his poor old hound lay beside him, run into the ground.

They lay in the grass of a deep hollow right between the two high

massifs. They seemed to hear the music of the wind blowing through the rocks a little above them. The hunter looked up to see two beautiful girls with redgold hair who had appeared out of nowhere. One of them had a fine young brindle deerhound on a leash. The other one spoke to him.

'Are you tired? You must be annoyed because your old hound let the big stag escape.'

'No, I'm sad that the hound is past it. His day has gone,' the hunter replied.

'Don't be sad,' said the girl, 'Take this hound with you, and there is no four-footed creature on the face of the earth, from the strong brown hare to the great red stag, which he won't catch for you.'

'What's his name?' asked the hunter.

'Brodum,' she said.

He took the leash out of the young girl's hand and thanked her for the hound. Then he said goodbye to her and her friend, and went downhill.

At first light next day, he woke the rest of his family and, bringing them out of the house, pointed to the two mountains between which he had seen the girls, saying, 'Do you see those two mountains facing you? From now on remember to call them *The Maidens*.' And that is what they're called right to the present day.

The brindle deerhound followed the hunter as long as he lived, and he thought he'd never put a slip leash on a better dog. He never asked anything of it that it refused to do, nor was it ever slipped after any creature that it could not catch. It would not follow or obey any man but one. When its master died, it lost heart. It followed his funeral as far as the waterfall between Callart and the next farm. But there it stopped, where it was seen going into a cave out of which it never returned.

It is remembered though, in the names of those two places, for they are still called *Brodum's Waterfall* and *Brodum's Cave*.

With that traditional story of how a man met the spirits of the mountains themselves, I'm reminded of a recent radio broadcast when the interviewer asked an ornithologist to recount the strangest experience he'd had while birdwatching. The ornithologist recounted how he and a friend had put up a hide in Kirkton Glen near Balquidder.

They went there early in the morning to make a list of all the different species of bird they could see, and they were using a telescope to identify them. Suddenly they saw a man with two deerhounds walking up the glen. They tried to find him with the telescope, but whenever they

thought they had him in sight, they lost him. Whenever they looked at him with the naked eye, they could both see him clearly. To this day they have no explanation for it, while the locals say a kilted hunter haunts the area.

My own thought is that it was a kind of trapped vision in the glen, a glimpse of a different time, and I composed the poem *The Spectral Hunter* to capture the sight of the hunter and his deerhounds who always remain the same, in the wild place where they belong.

# The Spectral Hunter

Two ornithologists survey
the rocks and trees,
looking down into the valley,
counting species.

A man walking up the Kirkton glen
with an early-morning stride
is seen by both of them
clearly on the hillside.

He has two deerhounds,
leggy, rockhard
tall dogs that bound
and are wire-scarred.

Two hounds of the crags
and a wind-wraith
rousing the stags
in Corrie Chaoraich.

Dogs without collars,
the gifts of two mountains,
one given by Meall Reamhar,
one by Meall an Fhiodhain.

He sets his own pace,
headlong streams and rain,
the valley graced
by the hunter again.

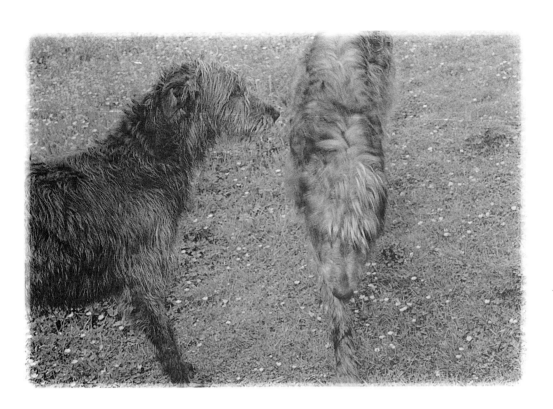

# Deerhounds

Long dogs, you move with air
belling the vault of your ribcage.
You subdue the miles below your hocks.

Levelled out at speed across wayless country,
over the open grassmoor that is paradise,
the onset of your going undulates the ground.

The bracken hurdles below your height,
the rushes make way for you;
your keen eyes hold in sight the rapid hills.

Brace of deerhounds, a matched two.
Intent, all flame, is what quickens
those long throats thonged with leather.

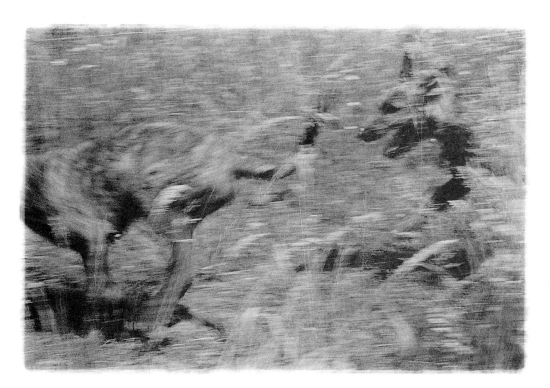

# A Year's Work

the rush of lambing
the driving of ewes
the speaning of lambs
the dipping of flocks
the keeling of ruddles
the war against maggots
the clipping at the fank
the walking of hills
the selling of shearlings
the gathering of a hirsel
the dressing of sticks
the quiet of the back-en'

# The Fairy Dog

'Thig là a' choin duibh fhathast.' Gaelic proverb
(The black dog's day will come.)

So you are a rich man's favourite dog
but we see you are a fairy dog
by your blue-black coat
your havana-brown eyes
you hop over from the otherworld
black dog for the light to land on

you're after us from the odd knoll
in the field of the rising music

So you are the landowner's dog
among his shotguns and his 4 x 4s
but we see by the way you run
your sooty pelt begins to smoke
the green flame at your jaws
black dog, your day will come

dog's bark, leading the way
red tongue, you lick us up

# Poacher's Poem

*Is soilleir cù dubh air liana bhàin*
*Is soilleir cù bàn air liana dhuibh,*
*Na'm bithinn ri fiadhach nam beann*
*Be'n cù riabhach mo roghainn.*

A snowy field shows up the sable hound
The white dog's seen on dusky ground.
The brindle hound will be my choice
To hunt in the moorland's own disguise.

snow leaper

# Atom

Bec took a photo of her cat for Christmas cards
Atom, a tomcat, mackerel tabby
with *new cat on the block* engraved on his ID disc
– though he lives in the country –
whiskers and snowflakes in deep December

When she'd made the prints and sent them off
we all noticed the unexpected
in the sparse fur inside his right ear
he showed the image of a child
a cherub leaning there light as a breath

# Hannibal

Up the valley of the Fruid Water in the Tweedsmuir Hills, one of the most remote areas in the Borders, live Jean Robb and Hannibal. By a stand of Scots pines you turn in from the single-track road to Jean's whitewashed cottage and Hannibal's big modern stable. Jean is a scientist, an expert in mycotoxins, whose lab analyses grass samples in the hunt for a solution to that mystery disease, 'grass sickness', which has killed so many well-loved horses. She has studied it all over Scotland and travelled to Patagonia to work with vets there too. The international research is funded by everybody in the horse world, from children who have lost a single pony, to the sheiks of the racing empire.

In photos Hannibal always looks large, impressive, and as if he might be up to something. His life began as a dapple-grey foal in the mists of Ireland, and he was brought over by boat to Scotland at the age of six, about 1972, which makes him older than your average successful thirtysomething. In his first days in Scotland he was leading pageants for

children through the streets. Aged ten, he was sold to Johnny Corbett (now Lord Rowallan) and he will always belong to him, he just stays with Jean.

It was while Hannibal was with Johnny that he appeared as Drum Horse with the Ayrshire Yeomanry at the Edinburgh Tattoo. In the winter he towed one of Johnny's sons learning to ski (that is, when the son was learning to ski, not Hannibal).

Over twenty years ago, Hannibal was hunting two days a week with the Eglinton. Johnny was always keen to keep up and so Hannibal was put over barbed wire and big hedges, anything for a short cut! Hannibal is not a fast horse. He will jump over or through anything, though, and then stand waiting for other speedier horses to catch up with him. He is a good honest horse, he jumps what he is put at, he never refuses. He used to go show-jumping too, but his main role in life was as a hunter. Hannibal is very tolerant of dogs – he never tapped hounds! But if the dogs go off at the gallop, he will go too.

Jean was strolling over Hawkshaw one sunny day, where there are no roads, and her greyhound, two lurchers and the big horse were walking loose along with her, when suddenly a lone cross-country runner appeared, jogging across the valley. The dogs took off to greet him, and Hannibal cantered after him too. Jean has never seen anyone sprint so fast in her life. The athlete ran towards the river and took a phenomenal leap across the water, by that time the animals were enjoying his company and as he jumped they leapt alongside him, all reaching the far bank together. When he didn't stop to chat, they watched him as he flew down the glen towards the main road and disappeared, setting up a new world record over rough country.

Hannibal is always up to something, he's never just standing there in the field, turned out to grass. If Jean rides out with other horses, he can still walk faster than them any day. He loves his food, and he can open gates, or the back door. He will jump ditches for fun, doing a series of high kicks afterwards. He can give the biggest buck. When the RAF fly at low level just above the stable roof, however, Hannibal stands quietly in the field, giving a quizzical look at the sky, while my daughter Mairi is sitting bareback on him, watching the jets. Occasionally, the planes scare the goat kids who share the fields with him, and they scuttle for shelter underneath him like white chicks. In fact, he does have a little Maran hen who keeps him company in the stable at night and lays an olive-green egg in the straw without being trodden on.

Hannibal nods good morning to you, and he tolerates child grooms, one on top, one below, little children scrubbing and brushing him. When it's school bus time, the driver will slow up for him, lean out and pat him, and the children speak to him as they pass. People have ridden him who've never sat on a horse before. Young Lee and Rachel from the next cottage take him for a walk and tell him off, 'Don't do that, Hannibal!' if he pulls them along.

He has a mind of his own, too. At the Dick Vet, three vet students were trying to hold him for examination and he lifted them all at once and carted them through the stable door. The college groom retells this story with great glee.

Hannibal comes to the cottage door and pushes inside as far as he can reach, to watch us prepare supper. Once Liam was trying to enter the house but couldn't get in because of Hannibal in the doorway. At the same moment, Jean asked Hannibal, 'Do you want to come in, dear?' To which Liam, hidden from view by Hannibal's huge bulk, replied 'Yes, I do!' in a deep bass Hannibal voice. All the women in the kitchen

– teenagers, Jean and myself – were completely taken in. Then we looked at each other and fell about laughing.

There's always a running battle with the farrier, because Hannibal likes to lean on him while he is working. The new stable has been built because Hannibal kept leaning on the sides of the old one till they bowed out. At dusk he rubs against his favourite tree and shakes all the bantam hens out of their roost in the lower branches.

Once he nearly wrecked a boat...but that was on his greatest adventure, a charity ride of 2,000 miles around Scotland, the 'Milestone Horsetrek', to raise money for specialist hospital equipment for children. Brother and sister Miles and Lucy Montgomery wanted to explore more of Scotland – but not to walk! Here is Lucy talking about their trek:

'We had Jorgita, a funny-coloured mare recently arrived from Argentina. Terrified of hills (caused her extreme vertigo) and a great fear of bogs. And Hannibal, 30-ish at the time, with one collapsed lung but about the only horse up to Miles' size (6ft 4).

Hannibal and Jorgita had the most extraordinary relationship which didn't change for the whole 6 months they were together. Hannibal completely adored her, despite the fact that she kicked him a few times each night (when we brushed him in the morning we found hoof prints all over his body!) Luckily, because he looked like a white rhino in comparison to gazelle-like Jorgita, he didn't seem to mind at all.

There was one occasion, however, when we were only able to find a very small, grassless courtyard for them to spend the night in, and an enormous fight ensued. On hearing the noise (which was impressively loud) we split them up and made an enclosure for Hannibal. As soon as they were apart, they called each other all night, and we found them together in the morning, surrounded by the debris of the two, painstakingly-built, 'Hannibal-proof' pens.

Hannibal was completely loose for most of our trip as his adoration of Jorgita ensured his return, at some point, usually galloping off the top of a nearby hill and down through an extremely deep treacherous bog. We always found safe and clever ways across bogs, which Hannibal ignored.

He picked up a few very bad habits on our trip. Crossing (loose and in front of us) very old and precarious bridges barely up to our weight. Walking over cattle-grids even when the gate beside them was open. An obsession with our 'survival mix' of chocolate, nuts and raisins. We'd

look around and he'd be nowhere in sight, but as soon as we surreptitiously produced the plastic bags and tried to eat, his bearded head was in the bag. It was unfair, particularly as the horses were being fed racehorse cubes and Miles and I had virtually nothing!'

Lucy considers that Hannibal is not only intelligent but also that he is an amazing character, and she adds, 'We all know animals feel most of the same emotions as people (if slightly differently!)' He was the pack horse who carried everything they needed on their 2,000 miles around Scotland. When they turned him loose, he followed them through the hills and cantered to catch up with the polo-pony Jorgita, all their food and gear clattering on his back.

Jean has spent a lifetime looking after thoroughbred racehorses, but with Hannibal she can enjoy their daily rides through the Tweedsmuir Hills. The country is so difficult she will often dismount to let him come down the steep brake or reverse back out of the bog. He can take care of himself. He has no bother finding his own way.

There are other days when Hannibal stands in his luxurious stable, watching Jean carrying buckets and wheeling barrows. Once man took the horse and made him work, now the horse makes woman work for him!

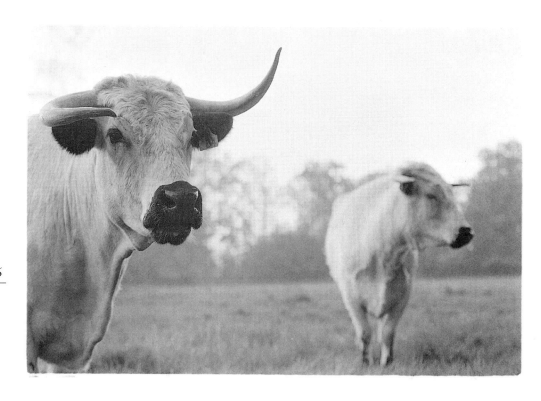

# White Park Cattle

2 black eyes
+ 1 black nose
+ 2 black ears
+ 4 black hooves
= whitey

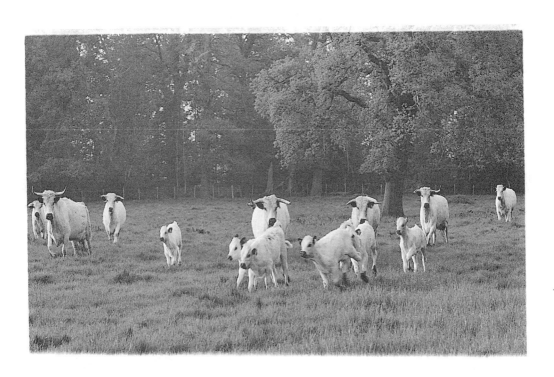

aurochs of my dreams

# Gie us Milk

*(from the Gaelic milking song* Thoir am Bainne)

Ma hinnie sall hae caufs wi white cluifs
an a band tae gae bonnilie roon her haughs
nae bourach o herr nor hather, o lint nor strae
but a tedder o silk brocht frae ower the border
    O ho ower the border!

    Gie us milk, broon coo
    lat doon strin and strone
    gie us milk, broon coo
    wat the bairnies mou!

Ma crommie sall hae girse an fauld
she sall hae hicht an howe an white grun
she sall hae blawgress, windlestrae an stibble
she'll hae a sowf o mountain dew frae the stey braes
    O ho the stey braes!

    Gie us milk, broon coo
    lat doon strin an strone
    gie us milk, broon coo
    wat the bairnies mou!

# stand and stamp

walk up to them,
your brown sheep will scatter,
your white will stand and stamp

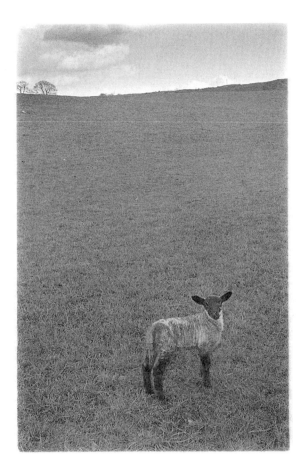

lammermuir lion

# Young Farmer at the Cashmere Goat Sales

He's clean of limb, and his newshaven chin rests on his hands
That fold over the long crook at throat-height. He stands
In his turned-up hillboots, bestrides this slippery deck,
Colossus in tweeds, with a camera and a thousand-pound cheque.
He moves the crook to stir the beasts about some,
Telling by their big knees if there's more growth to come.

He tries their coats between forefinger and thumb,
The long white topfleeces like a spiral perm.
He feels for the dense handful of cashmere beneath,
Combs the riches per ounce these male kids will bequeath.
A young girl hangs over the corner-rail to hear his jargon:
He reaches a finger to her hair, to gauge the first carding.

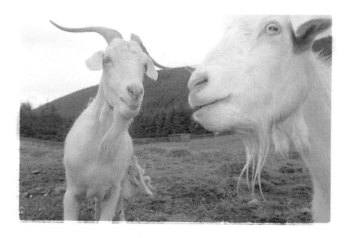

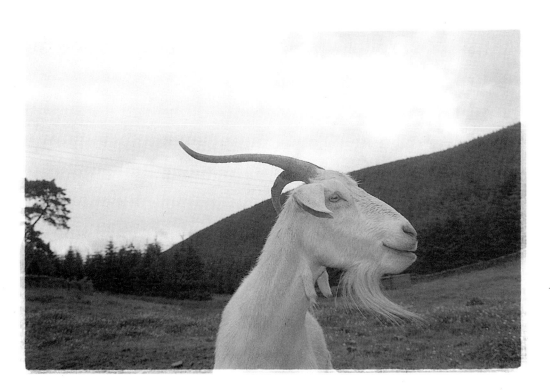

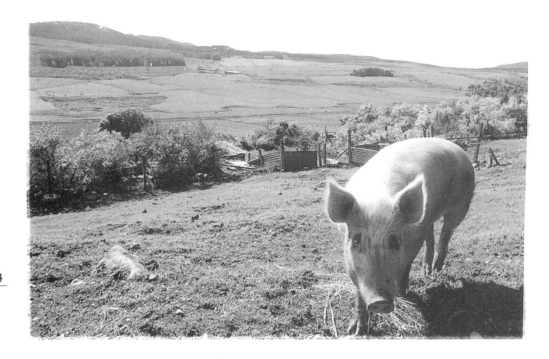

# Free Range Pig

the dancing pig
sunrise-red hide
and a percussion of trotters

## Hen Text Message

scrc s hns tth

# Broody

leerie law
day today
the cocks tae craw
the hens tae lay

# Invisible Fly

scribbling on a green field
the white hen chases
an invisible fly

# Clydesdale Clydesdale

Are there Clydesdales still in Clydesdale, where they were first bred in the middle of the 18th century? Together with Liam my husband, we're off to Lanarkshire to see the indigenous breed for ourselves, on a September day when we might hope to find this year's foals with the mares. I've made up a picnic of salad baps, maple syrup biscuits, grapes, Appletise in a chill-bag. There's brilliant sunshine at Fallburn, with twa-three men herding sheep into the fank. I lean on the elbow-gate and look up the footpath to the top of Tinto Hill. This is the hill I watched from where I grew up, now the hill I climb each year on my birthday. And when I had 'one more mountain to climb', I climbed it in my mind through each chemotherapy treatment, a hill of steep gradients. I look up, just beginning to believe I'm here.

We're driving through a country of rough moorland, rounded hills with shapely summits that slope down to richer pasture where the young Clyde winds between grassy knolls and banks and runs past ridges of

gravel. There are hidden scarps and gravel pits and quarries, as well as rolling fields. The road dips down to *The Boat* farm and on to Covington Mill. Here are green fields with brown and roan Clydesdales in them.

Mrs Jackson has told us how to find our way to them: 'look for the farm garden with two swans in it.' Two home-made plaster swans, a mass of honeysuckle obscuring an entrance marked by giant millstones. On the threshold of the farmhouse I tap the old brass piper doorknocker on toffee-coloured paintwork.

When she opens the door, Mrs Jackson is a strikingly beautiful woman; her face gleams with the health of outdoor work. Blue eyes, tanned skin, silver hair tied high in a bun. Strong arms greater than her small hands: arms for grooming, hands for foaling. At her ears and on her finger, lucky golden earrings and a ring, horseshoes with every nailhead picked out in detail. Open horseshoes, ready to catch good fortune. A sign of her power, queen of Covington, lady of the thirteen horses, with a royal face like a Boudica whirling by in her chariot.

She welcomes us in, to show us photos of the horses. It was her younger son, she says, who went to the winter fair and chose a filly foal eighteen years ago. They weren't horse people but she said she'd help him. They already showed sheep and cattle. Well, that was their first brood mare, they took her to the Highland Show a year after they had her, it was their neighbour who said, 'She'll not shame you there'. And she got Second Prize right away.

There are championship photos, and 'at home' photos of this year's mares and foals, a flurry, a frolic of six mares and six big foals all in the same field together. In the hallway stands an antique dresser heaped with the current prize cups. One with a tiny helmet atop seems familiar to me, I recall seeing one like it in photos of a farmer friend, Geordie from Ayrshire, with his winning Clydesdales in the 1920s. I read the first inscription on it, '1898'. Over a hundred years of breeding, of striving for perfection, of all the work that turns out a horse ready for farm work or for the show-ring. How many times has the cup returned to this valley?

I'm lucky enough to have read some of the original Clydesdale Stud Books of the 1880s, when these horses were to be seen everywhere in the streets of Glasgow, each one pulling a heavy cart which would usually have been drawn by two lighter horses, yet stepping out easily at

work. The Stud Books give the pedigrees of stallions with names such as Mickle Samson, Old Clyde, Rantin Robin, with accurate details of their colouring: 'Black Watch, black, white star on forehead'. The mares have similar entries, but they are named Lovie, Hazelnut, Rosa, Ellen Terry or Bessie Bell. In copper-plate handwriting alongside are the signatures of owners and breeders, and sometimes a sad note, 'died 1905' or, more often, a proud one, 'exported to South America…Russia…Canada…Australia…USA.' Here is mention of 'Mr Scott's Blaze', or 'Glancer' and the breed is described as 'very wise between the shafts', while we are reminded that the horse is 'seen to best advantage at his work.'

Mrs Jackson puts us in her Peugeot, that way we can all go together up to the field where most of the horses are. We coast along. And here they are in the rich grasslands, lifting their heads, recognising her, and moving freely towards us, huge gentle giants. I have a big bag of carrots for them, breaking them into chunks for the mares. The foals look big but they are not ready for carrots yet, though they do want to be patted. 2lb carrots away already!

We saunter through the fields with them. They're drinking, dribbling trickles of water from their lips above the trough, grateful for it in this

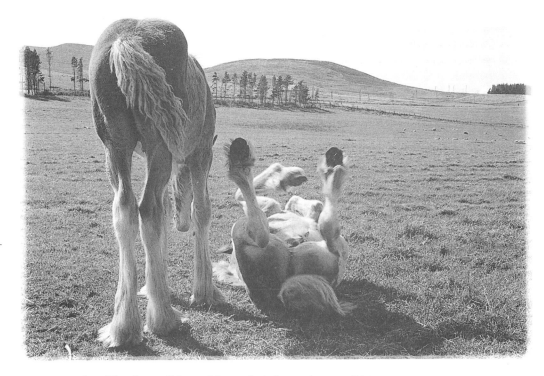

warm weather. They're walking with us, their heavy hooves lifting cleanly, with the inside of each hoof visible to anybody walking behind. A ploughman's view of Scotland. Good sound well-shaped hooves, feathered white. The youngsters rub their tufted woolly foal-tails on the fence. The foal rolling his ruggled coat in the grass shows he's at ease in our company.

Grooming each other, they wreathe perfect heads and crested necks, paired in symmetry, responding each to each in a Celtic knotwork of long active ears, clear eyes, bristling manes. The great mares feed on a fertile rise where their long sloping withers mimic the line of Quothquan Law summit behind them.

Tinto's magnificent dome overlooks the Clyde. Flesh-coloured flanks and a roan rump and the top of the withers in an undulating land of light, all good ground, every hill setting off another and another.

Mrs Jackson has discovered that Liam's parents farmed in Argyll, she's from Campbelltown herself. She suggests that we buy one of the farms

for sale near them, 'You'd be nice neighbours,' and settle here. She drives us around a hinterland of farm roads to see a newly restored mill and a farmhouse that looks out to the hills. Nearby Cormiston Farm is for sale, but it is a huge working farm.

We return to Covington by the back road, to see the colts and the big brown stallion in the stables. The dark colt is turning darker, so handsome with a white blaze down his Roman nose. I offer him a bit of baby carrot in my palm. He's never tried it before. Tentatively, he lips and tastes it first. Then he decides to crunch it up, likes it and wants more. His muzzle is sticky with a dusting of bran mash on it, he's like a baby tasting new foods. He was speaned (separated from his mother) a week ago. If his coat turns true black, there's a purchaser who wants him.

Mr Jackson comes in to say if we want to buy a foal, it could stay here, they can keep it for us, show it, everything. He's not a horseman himself, he was up on a tractor as a youngster. But the state farming is in these days, the horses and their success in the shows 'keep us from going mad'. At the big shows, mind, 'these horsemen, they'd string you up rather than let you win.' He's visibly proud of Mrs Jackson's success.

Out in the fields again, I am admiring a great character, the eighteen year-old mare who is grazing alongside the infant River Clyde. She's tall and elegant, with a ringled eye and her roan coat splatched with white. The length of her legs, the way she moves along all smoothly in the sunlight shows an action that could set little brasses swinging on the swingletree, if she were in harness. Mrs Jackson takes her by the forelock and leads her out into mid-field. She's their original brood-mare, and they hope for one more filly foal from her next year.

There's coffee and food ready for us in the farmhouse kitchen: home-made pancakes and raspberry jam, crispy cakes, chocolate slice…a feast. But I can hardly eat for gazing at the view out the window to see the grand shape of Tinto rising like a deep breath. Airy country opening out to the perfect hill. The late summer afternoon light splashes everywhere, the Clyde turns blue. Mrs Jackson tells us show stories, foaling stories. Her caravan stands right by the sheds at foaling time, for her to be ready if they fall with the skin over their heads or if the mare lies up against the wall.

Next day finds me indoors once more, in hospital arts work. I lift my head for a moment and I'm seeing Covington again, daydreaming of Cairngryffe Hill. Here the hill-fort was quarried away to reveal, inside,

the knob-head of a linch-pin, the bronze terret, the horse-harness trappings buried for 2,000 years. To think of the great draught horses being bred in the valley alongside it today! Bronze horses with legs of white metal, hooves newly shod with iron. Each one waiting for a ploughman, a carter, a horseman to work with every day, ploughing, sowing, reaping. We humans have changed faster than the horses.

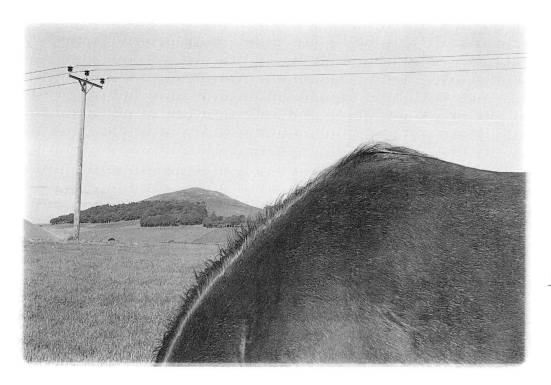

# Clydesdale Clydesdale

Flanks of the hill fall sharply to the bank,
a bend in the river. The summit, the withers.
The scarp line, the crest of a mane.

River-valley, a broad back. Home pastures
where grass, soil, moisture,
everything helps to grow a good horse.

Light wands waver through slatted sheds.
The dark colt turns blacker,
a white blaze runs down his face.

The Brow Burn shines beside fertile rises.
Somewhere near, there's the bronze figurine
of a horse still to discover.

# Mute Swans, Tame Swans

sounder                                    sounder

soarer                        soarer

hisser            hisser

surger

surger

resounder            resounder

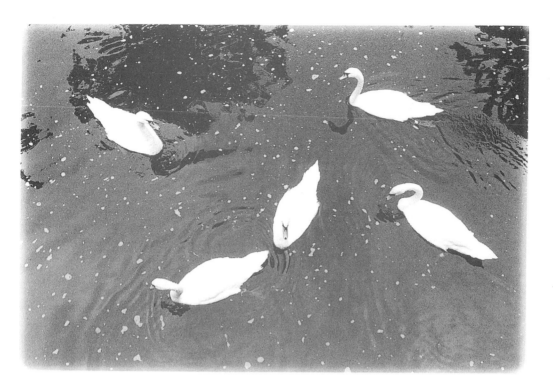

# Dolly's Herd

*Animals are the creatures that human beings identify with most closely: livestock form one of the most important components of the world's economy, and indeed of its ecology, and human beings, of course, are animals too.*

Professor Ian Wilmut, OBE, Roslin Institute from *The Second Creation* by I. Wilmut, K. Campbell, C. Tudge (Headline, 2000)

How to
pharm
the rarest
lambs ever born
– white all over
very tame and trusting
with their coiled fleece
the double helix –
who'll change
all our
lives

Bushy-
bearded Ian's
shaky hand
holds a pipette
with a tip of ten microns
instead of a shepherd's crook
he signals to the cells
places eggs in a dish
he can just see them
because they
shine

Oocytes
oh-oh sites
a whole team of
hollow blastocysts.
Our powers are changing
postponing death
getting lost in the unknown
genome and
finding
the
way

Nature
is quirky –
testing ideas in winter
some of the team sleeping
in the office by the sheep sheds
wait for signs of birth.
They dream of this
– making a lamb
by nuclear transfer
from an
adult
cell

Risk
frisky
science leaps and bounds
can make a copy of you
engineer tissue, repair skin burns
resist disease, bypass sex
create chimeras
– you won't need shoes
when you have hooves –
tomorrow is closer
than you
think

Angels' hands hold the lamb,
*Agnus Dei* emblem,
Rosslyn Chapel.

# Some other books published by **LUATH** PRESS

## 'Nothing but Heather!'

Gerry Cambridge

ISBN 0 946487 49 9 PBK £15.00

Enter the world of Scottish nature – bizarre, brutal, often beautiful, always fascinating – as seen through the lens and poems of Gerry Cambridge, one of Scotland's most distinctive contemporary poets.

On film and in words, Cambridge brings unusual focus to bear on lives as diverse as those of dragonflies, hermit crabs, short-eared owls, and wood anemones. The result is both an instructive look by a naturalist at some of the flora and fauna of Scotland and a poet's aesthetic journey.

This exceptional collection comprises 48 poems matched with 48 captioned photographs. In his introduction Cambridge explores the origins of the project and the approaches to nature taken by other poets, and incorporates a wry account of an unwillingly-sectarian, farm-labouring, bird-obsessed adolescence in rural Ayrshire in the 1970s.

*Keats felt that the beauty of a rainbow was somehow tarnished by knowledge of its properties. Yet the natural world is surely made more, not less, marvellous by*
*awareness of its workings. In the poems that accompany these pictures, I have tried to give an inkling of that. May the marriage of verse and image enlarge the reader's appreciation and, perhaps, insight into the chomping, scurrying, quivering, procreating and dying kingdom, however many miles it be beyond the door.*
GERRY CAMBRIDGE

*'a real poet, with a sense of the music of language and the poetry of life...'*
KATHLEEN RAINE
*'one of the most promising and original of modern Scottish poets... a master of form and subtlety.'*
GEORGE MACKAY BROWN

## On the Trail of Robert Service

GW Lockhart

ISBN 0 946487 24 3  PBK  £7.99

Robert Service is famed world-wide for his eye-witness verse-pictures of the Klondike gol-drush. As a war poet, his work outsold Owen and Sassoon, and he went on to become the world's first million selling poet. In search of

adventure and new experiences, he emigrated from Scotland to Canada in 1890 where he was caught up in the aftermath of the raging gold fever. His vivid dramatic verse bring to life the wild, larger than life characters of the gold rush Yukon, their bar-room brawls, their lust for gold, their trigger-happy gambles with life and love. 'The Shooting of Dan McGrew' is perhaps his most famous poem:

> *A bunch of the boys were whooping it up in the Malamute saloon;*
> *The kid that handles the music box was hitting a ragtime tune;*
> *Back of the bar in a solo game, sat Dangerous Dan McGrew,*
> *And watching his luck was his light o'love, the lady that's known as Lou.*

His storytelling powers have brought Robert Service enduring fame, particularly in North America and Scotland where he is something of a cult figure.

Starting in Scotland, *On the Trail of Robert Service* follows Service as he wanders through British Columbia, Oregon, California, Mexico, Cuba, Tahiti, Russia, Turkey and the Balkans, finally 'settling' in France.

This revised edition includes an expanded selection of illustrations of scenes from the Klondike as well as several photographs from the family of Robert Service on his travels around the world.

Wallace Lockhart, an expert on Scottish traditional folk music and dance, is the author of *Highland Balls & Village Halls* and *Fiddles & Folk*. His relish for a well-told tale in popular vernacular led him to fall in love with the verse of Robert Service and write his biography.

*'A fitting tribute to a remarkable man – a bank clerk who wanted to become a cowboy. It is hard to imagine a bank clerk writing such lines as:*
> *A bunch of boys were whooping it up...*
*The income from his writing actually exceeded his bank salary by a factor of five and he resigned to pursue a full time writing career.'* Charles Munn, THE SCOTTISH BANKER

*'Robert Service claimed he wrote for those who wouldn't be seen dead reading poetry. His was an almost unbelievably mobile life... Lockhart hangs on breathlessly, enthusiastically unearthing clues to the poet's life.'* Ruth Thomas, SCOTTISH BOOK COLLECTOR

*'This enthralling biography will delight Service lovers in both the Old World and the New.'*
Marilyn Wright, SCOTS INDEPENDENT

## Blind Harry's Wallace

William Hamilton of Gilbertfield

Introduced by Elspeth King

ISBN 0 946487 43 X   HBK   £15.00
ISBN 0 946487 33 2   PBK   £8.99

The original story of the real braveheart, Sir William Wallace. Racy, blood on every page, violently anglophobic, grossly embellished, vulgar and disgusting, clumsy and stilted, a literary failure, a great epic. Whatever the verdict on BLIND HARRY, this is the book which has done more than any other to frame the notion of Scotland's national identity. Despite its numerous 'historical inaccuracies', it remains the principal source for what we now know about the life of Wallace.

The novel and film Braveheart were based on the 1722 Hamilton edition of this epic poem. Burns, Wordsworth, Byron and others were greatly influenced by this version 'wherein the old obsolete words are rendered more intelligible', which is said to be the book, next to the Bible, most commonly found in Scottish households in the eighteenth century. Burns even admits to having 'borrowed... a couplet worthy of Homer' directly from Hamilton's version of BLIND HARRY to include in 'Scots wha hae'.

Elspeth King, in her introduction to this, the first accessible edition of BLIND HARRY in verse form since 1859, draws parallels between the situation in Scotland at the time of Wallace and that in Bosnia and Chechnya in the 1990s. Seven hundred years to the day after the Battle of Stirling Bridge, the 'Settled Will of the Scottish People' was expressed in the devolution referendum of 11 September 1997. She describes this as a landmark opportunity for mature reflection on how the nation has been shaped, and sees BLIND HARRY'S WALLACE as an essential and compelling text for this purpose.

'A true bard of the people'.
TOM SCOTT, THE PENGUIN BOOK OF SCOTTISH VERSE, on Blind Harry.

'A more inventive writer than Shakespeare.'
RANDALL WALLACE

'The story of Wallace poured a Scottish prejudice in my veins which will boil along until the floodgates of life shut in eternal rest.'
ROBERT BURNS

'Hamilton's couplets are not the best poetry you will ever read, but they rattle along at a fair pace.'

In re-issuing this work, the publishers have re-opened the spring from which most of our conceptions of the Wallace legend come.'
SCOTLAND ON SUNDAY

'The return of Blind Harry's Wallace, a man who makes Mel look like a wimp.'
THE SCOTSMAN

## Poems to be read aloud

Collected and with an introduction by Tom Atkinson

ISBN 0 946487 00 6   PBK   £5.00

This personal collection of doggerel and verse ranging from the tear-jerking Green Eye of the Yellow God to the rarely printed, bawdy Eskimo Nell has a lively cult following. Much borrowed and rarely returned, this is a book for reading aloud in very good company, preferably after a dram or twa. You are guaranteed a warm welcome if you arrive at a gathering with this little volume in your pocket.

'This little book is an attempt to stem the great rushing tide of canned entertainment. A hopeless attempt of course. There is poetry of very high order here, but there is also some fearful doggerel. But that is the way of things. No literary axe is being ground.

Of course some of the items in this book are poetic drivel, if read as poems. But that is not the point. They all spring to life when they are read aloud. It is the combination of the poem with your voice, with all the art and craft you can muster, that produces the finished product and effect you seek.

You don't have to learn the poems. Why clutter up your mind with rubbish? Of course, it is a poorly furnished mind that doesn't carry a fair stock of poetry, but surely the poems to be remembered and savoured in secret, when in love, or ill, or sad, are not the ones you want to share with an audience.

So go ahead, clear your throat and transfix all talkers with a stern eye, then let rip!'
TOM ATKINSON

# NEW SCOTLAND

**Scotland - Land and Power
the agenda for land reform**
Andy Wightman
foreword by Lesley Riddoch
ISBN 0 946487 70 7  PBK  £5.00

**Old Scotland New Scotland**
Jeff Fallow
ISBN 0 946487 40 5  PBK  £6.99

**Notes from the North
incorporating a Brief History of the
Scots and the English**
Emma Wood
ISBN 0 946487 46 4  PBK  £8.99

# HISTORY

**Reportage Scotland**
Louise Yeoman
ISBN 0 946487 61 8  PBK  £9.99

**A Word for Scotland**
Jack Campbell
foreword by Magnus Magnusson
ISBN 0 946487 48 0  PBK  £12.99

# SOCIAL HISTORY

**Shale Voices**
Alistair Findlay
foreword by Tam Dalyell MP
ISBN 0 946487 63 4  PBK  £10.99
ISBN 0 946487 78 2  HBK  £17.99

**Crofting Years**
Francis Thompson
ISBN 0 946487 06 5  PBK  £6.95

# LUATH GUIDES TO SCOTLAND

**Mull and Iona: Highways and Byways**
Peter Macnab
ISBN 0 946487 58 8  PBK  £4.95

**SouthWest Scotland**
Tom Atkinson
ISBN 0 946487 04 9  PBK  £4.95

**The West Highlands: The Lonely Lands**
Tom Atkinson
ISBN 0 946487 56 1  PBK  £4.95

**The Northern Highlands: The Empty
Lands**
Tom Atkinson
ISBN 0 946487 55 3  PBK  £4.95

**The North West Highlands: Roads to the
Isles**
Tom Atkinson
ISBN 0 946487 54 5  PBK  £4.95

# TRAVEL AND LEISURE

**Edinburgh's Historic Mile**
Duncan Priddle
ISBN 0 946487 97 9  PBK  £2.99

**Edinburgh and Leith Pub Guide**
Stuart McHardy
ISBN 0 946487 80 4  PBK  £4.95

**Pilgrims in the Rough: St Andrews
beyond the 19th hole**
Michael Tobert
ISBN 0 946487 74 X  PBK  £7.99

# WALK WITH LUATH

**Mountain Days & Bothy Nights**
Dave Brown and Ian Mitchell
ISBN 0 946487 15 4  PBK  £7.50

**The Joy of Hillwalking**
Ralph Storer
ISBN 0 946487 28 6  PBK  £7.50

**Scotland's Mountains before the Moun-
taineers**
Ian Mitchell
ISBN 0 946487 39 1  PBK  £9.99

# LUATH WALKING GUIDES

**Walks in the Cairngorms**
Ernest Cross
ISBN 0 946487 09 X  PBK  £4.95

**Short Walks in the Cairngorms**
Ernest Cross
ISBN 0 946487 23 5  PBK  £4.95

# FICTION

**But n Ben A-Go-Go**
Matthew Fitt
ISBN 0 946487 82 0  HBK  £10.99

**The Bannockburn Years**
William Scott
ISBN 0 946487 34 0  PBK  £7.95

**The Great Melnikov**
Hugh MacLachlan
ISBN 0 946487 42 1  PBK  £7.95

**Grave Robbers**
Robin Mitchell
ISBN 0 946487 72 3  PBK  £7.99

## NATURAL SCOTLAND

**Wild Scotland: The essential guide to finding the best of natural Scotland**
James McCarthy
Photography by Laurie Campbell
ISBN 0 946487 37 5  PBK  £7.50

**Scotland Land and People**
**An Inhabited Solitude**
James McCarthy
ISBN 0 946487 57 X  PBK  £7.99

**The Highland Geology Trail**
John L Roberts
ISBN 0946487 36 7  PBK  £4.99

**Rum: Nature's Island**
Magnus Magnusson
ISBN 0 946487 32 4  PBK  £7.95

**Red Sky at Night**
John Barrington
ISBN 0 946487 60 X  PBK  £8.99

**Listen to the Trees**
Don MacCaskill
ISBN 0 946487 65 0 PBK   £9.99

## FOLKLORE

**The Supernatural Highlands**
Francis Thompson
ISBN 0 946487 31 6  PBK  £8.99

**Scotland: Myth, Legend and Folklore**
Stuart McHardy
ISBN: 0 946487 69  3  PBK  7.99

**Tall Tales from an Island**
Peter Macnab
ISBN 0 946487 07 3  PBK  £8.99

**Tales from the North Coast**
Alan Temperley
ISBN 0 946487 18 9  PBK  £8.99

## BIOGRAPHY

**Tobermory Teuchter: A first-hand account of life on Mull in the early years of the 20th century**
Peter Macnab
ISBN 0 946487 41 3  PBK  £7.99

**Bare Feet and Tackety Boots**
Archie Cameron
ISBN 0 946487 17 0  PBK  £7.95

**Come Dungeons Dark**
John Taylor Caldwell
ISBN 0 946487 19 7  PBK  £6.95

## MUSIC AND DANCE

**Highland Balls and Village Halls**
GW Lockhart
ISBN 0 946487 12 X  PBK  £6.95

**Fiddles & Folk: A celebration of the re-emergence of Scotland's musical heritage**
GW Lockhart
ISBN 0 946487 38 3  PBK  £7.95

## SPORT

**Over the Top with the Tartan Army (Active Service 1992-97)**
Andrew McArthur
ISBN 0 946487 45 6  PBK  £7.99

**Ski & Snowboard Scotland**
Hilary Parke
ISBN 0 946487 35 9  PBK  £6.99

## ON THE TRAIL OF

**On the Trail of William Wallace**
David R. Ross
ISBN 0 946487 47 2  PBK  £7.99

**On the Trail of Robert the Bruce**
David R. Ross
ISBN 0 946487 52 9  PBK  £7.99

**On the Trail of Mary Queen of Scots**
J. Keith Cheetham
ISBN 0 946487 50 2  PBK  £7.99

**On the Trail of Robert Burns**
John Cairney
ISBN 0 946487 51 0  PBK  £7.99

**On the Trail of John Muir**
Cherry Good
ISBN 0 946487 62 6  PBK  £7.99

**On the Trail of Bonnie Prince Charlie**
David R. Ross
ISBN 0 946487 68 5  PBK  £7.99

**On the Trail of Queen Victoria in the Highlands**
Ian R. Mitchell
ISBN 0 946487 79 0  PBK  £7.99

## **Luath** Press Limited

*committed to publishing well written books worth reading*

LUATH PRESS takes its name from Robert Burns, whose little collie Luath (*Gael.*, swift or nimble) tripped up Jean Armour at a wedding and gave him the chance to speak to the woman who was to be his wife and the abiding love of his life. Burns called one of *The Twa Dogs* Luath after Cuchullin's hunting dog in *Ossian's Fingal*. Luath Press grew up in the heart of Burns country, and now resides a few steps up the road from Burns' first lodgings in Edinburgh's Royal Mile.

Luath offers you distinctive writing with a hint of unexpected pleasures.

Most UK and US bookshops either carry our books in stock or can order them for you. To order direct from us, please send a £sterling cheque, postal order, international money order or your credit card details (number, address of cardholder and expiry date) to us at the address below. Please add post and packing as follows: UK – £1.00 per delivery address; overseas surface mail – £2.50 per delivery address; overseas airmail – £3.50 for the first book to each delivery address, plus £1.00 for each additional book by airmail to the same address. If your order is a gift, we will happily enclose your card or message at no extra charge.

**Luath** Press Limited
543/2 Castlehill
The Royal Mile
Edinburgh EH1 2ND
Scotland
Telephone: 0131 225 4326 (24 hours)
Fax: 0131 225 4324
email: gavin.macdougall@luath.co.uk
Website: www.luath.co.uk